IMAGES
of America

FORDS

IMAGES
of America

FORDS

Joanne De Amicis Bulla

ARCADIA

First printed in 2002.

Published by Arcadia Publishing,
an imprint of Tempus Publishing, Inc.
2A Cumberland Street
Charleston, SC 29401

Printed in Great Britain.

Library of Congress Catalog Card Number: 2002103925

For all general information contact Arcadia Publishing at:
Telephone 843-853-2070
Fax 843-853-0044
E-Mail sales@arcadiapublishing.com

For customer service and orders:
Toll-Free 1-888-313-2665

Visit us on the internet at http://www.arcadiapublishing.com

This book is dedicated to John A. De Amicis, who bought a new house in Fords in 1960 and chose to raise his family there. He always tried to instill in his children the ideals he lived by—hard work and strength of character make good people. We could not have had a better teacher.

CONTENTS

ACKNOWLEDGMENTS

I was lucky to have spent most of my childhood in Fords. We lived in a new house in one of the housing developments of the 1960s. I attended both Lafayette Estates School No. 25 and Our Lady of Peace School. Our family could shop and play in town or jump into the car and drive to New York or the Jersey shore in an hour or less. Fords was a great place in which to grow up.

I would like to acknowledge the people who were so accommodating in providing me with photographs and information; without them, this history of Fords would not have been possible. They include Fords Fire Company No.1 members Carlo Conrad, Frank Wehrle, and especially Frank Della Pietro, who was always willing to help with time and knowledge; Rita Bihary of the First Presbyterian Church; the women in the office of Our Lady of Peace Church; Wenda Rottweiler of Woodbridge Public Library; Tom Gockel, who worked for the Fords Post Office; Steve Kermondy, who works for the library; and my friend Terry Koebel.

Freeholder Pete Dalina was especially helpful, as was his son, Stephen. Thanks also go to the following: my stepmother, Grace, for her willingness to follow up on requests for pictures; my husband, Joseph, for all his support and encouragement and for putting up with a house full of photographs and notes; and editor Susie Jaggard of Arcadia Publishing for her assistance and patience. Without the help and enthusiasm of all of these people, the book would not have become a reality.

INTRODUCTION

Fords is part of the oldest original township in the state of New Jersey, Woodbridge. The history of the town is closely tied to the history of the township. The earliest inhabitants, after the signing of the charter with King Charles II of England, were farmers who quietly tended their fields and their herds. Fords remained mostly a rural area through the Revolutionary War, the Civil War, and World War I. The main industry was clay mining. Those who did not farm worked in the clay pits or in the clay-manufacturing factories in other parts of Woodbridge or Perth Amboy. Women baked their own bread and canned the produce from their own gardens. Over time, things started to change. People no longer needed to travel to other towns for goods because stores opened up in downtown Fords on New Brunswick Avenue and King George Road. As the population increased, so did the goods available to Fords residents, right in their own hometown. After World War II, Fords grew as highways made commuting easier and housing developments sprang up on former farmland. Churches and schools had to be expanded to keep up with the growing population. Fords became a suburban community.

Throughout its history, Fords always maintained its own character. This town went from being known as Sling Taile (after a small stream running through it) to Fords Corner (after one of its families) to Sand Hills (after an area on King George Road) and, finally, to Fords. The story of the town emerges as the story of the people who lived there—not the rich and celebrated, not necessarily the well known, but the average folks who lived and worked and built the Fords of today. Their contributions to schools, churches, clubs, the fire company, first-aid squad, and businesses are what made the town unique, and this is their story.

One

HOMES, BUSINESS, AND TRAVEL

The seal of Woodbridge Township shows the importance of the clay and brick industries to the development of the municipality. The seal incorporates a pick and shovel for the clay-mining aspect and a kiln for the brick-making industry. The designers chose these depictions because they recognized how important the industries were in bringing people, homes, and businesses to the township.

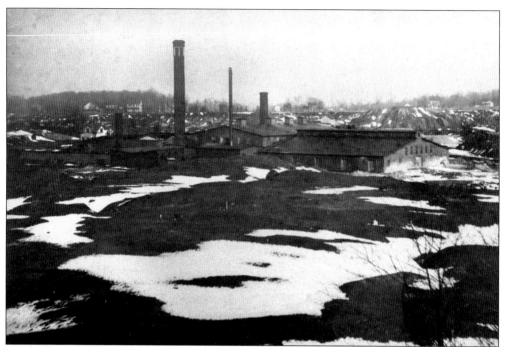

Clay pits, which were dug in Fords as well as in Woodbridge during the 19th century, provided the raw material for the clay product manufacturing industry that helped put the township on the map. The rich deposits of clay found here made clay mining and brick manufacturing the main industries of the area. (Courtesy Woodbridge Public Library.)

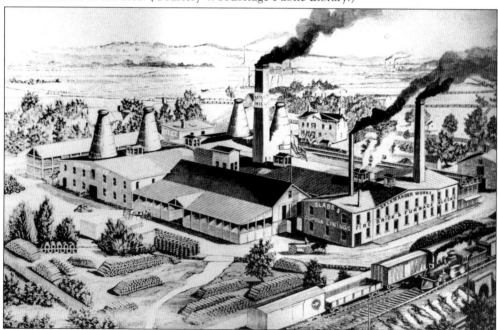

The Salamander Works, located in Woodbridge, utilized much of the clay mined in the clay pits of Fords and of Woodbridge. Started by Gage Inslee and Rene Parusses, the factory made stoneware and firebrick. (Courtesy Woodbridge Public Library.)

10

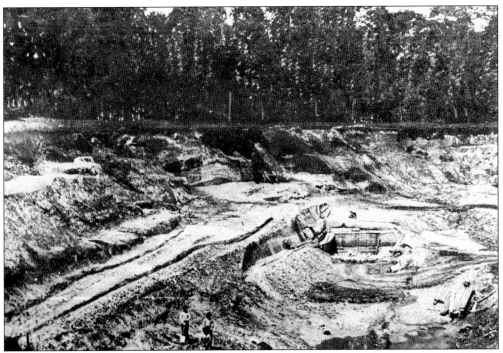

Clay mining provided work for many men, although the jobs were hard and dirty. Irish and German immigrants were among the first to take jobs in the clay pits. They were followed by Hungarian immigrants in the later 1800s. The influx of immigrants who came to work in the clay industry aided the growth of Fords and neighboring towns. (Courtesy Woodbridge Public Library.)

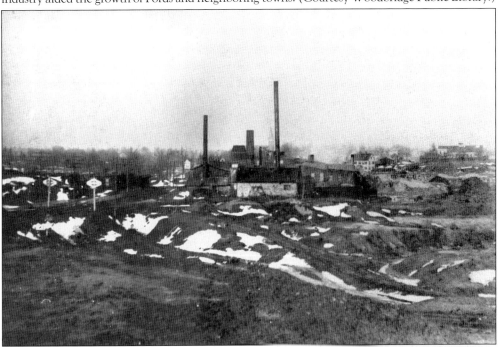

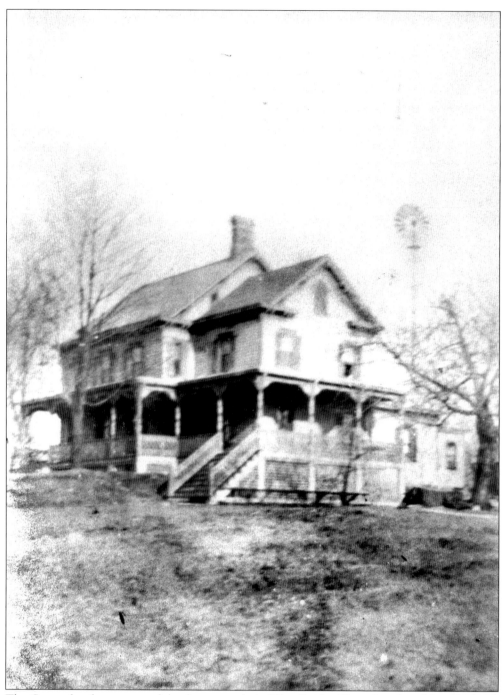

The Cutter family was one of the first to settle in Woodbridge Township from New England. Richard Cutter built a gristmill with John Pike in 1710. Shown is the Cutter House in 1890. It is unknown whether the original Cutter home, from the early 1700s, was replaced or just enlarged to become the present house. Rebecca Dunn Cutter was born in the house on October 31, 1821. Her family lineage included a "Surgeon of State Troops" who served in Heard's Brigade during the Revolutionary War. (Courtesy Woodbridge Public Library.)

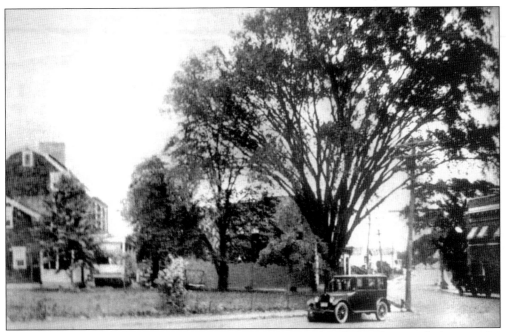

This elm tree stood at the intersection of King George Road and New Brunswick Avenue, the place known as Fords Corner. The house behind the tree belonged to the Liddle family and was built prior to 1804. The tree stood for more than a century before being chopped down in November 1954 to make way for the First National Bank. (Courtesy Woodbridge Public Library.)

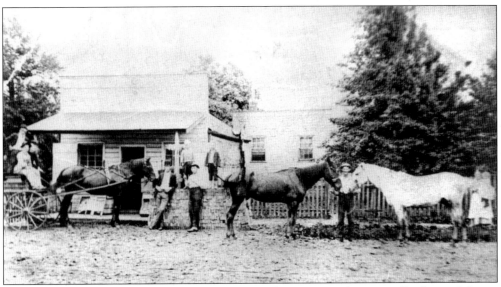

In 1889, the Fullerton house stood on New Brunswick Avenue, at the time still a dirt road. Later, the Fords movie theater occupied this site. Identified in the photograph are Fannie Olsen, holding the reins of the horse; Will Cochinberry and Sandy Halligan, in the wagon; John Olsen (left) and James Egan, leaning on the brick pile; Ballantine Hamilton (left) and Robert Fullerton, on top of the bricks; and William Fullerton, holding the two facing horses. The others are Fullerton family members and acquaintances. (Courtesy Woodbridge Public Library.)

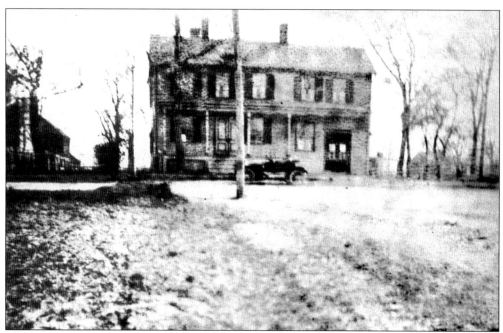

Wheelman's Rest-Egan's Saloon was located on the south side of New Brunswick Avenue opposite Corrielle Street. (Courtesy Woodbridge Public Library.)

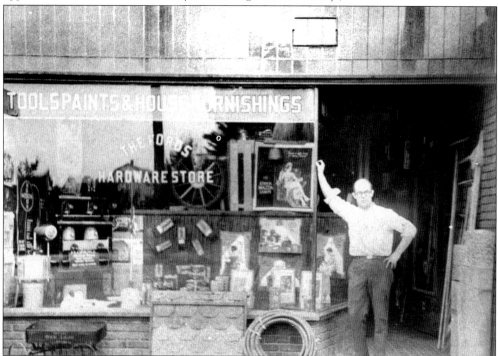

Although known as Rosenbloom's Hardware, the window sign identifies the store as Fords Hardware. Here one could purchase anything from paint and brushes to household goods, lamps, tools, and that hard-to-find nut or bolt of just the right size. Located on New Brunswick Avenue, this was the first hardware store in Fords. (Courtesy Woodbridge Public Library.)

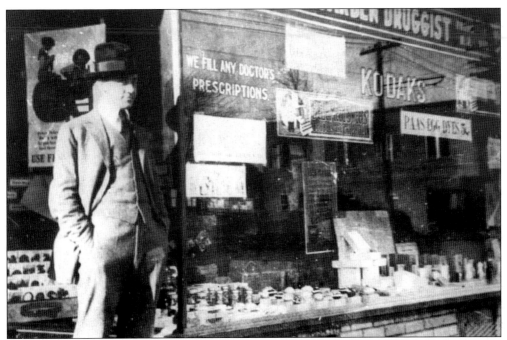

Garben's Drug Store was located on New Brunswick Avenue. In addition to medications, it carried candy, photographic supplies, and a variety of items—much like the drugstores of today. An advertisement for Easter egg dye touts the price as 5¢. (Courtesy Woodbridge Public Library.)

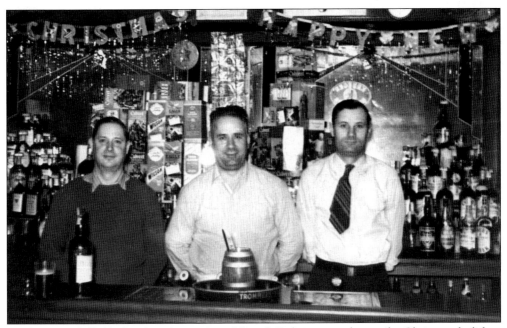

Brothers Frank (left), Stephen (center), and Joseph Dalina pause during the Christmas holidays in 1934, the year they opened their tavern on Crows Mill Road. Note that they were willing to cash checks for the price of a nickel. Many working men would stop at this or other taverns in Fords on the way home from work. (Courtesy Pete Dalina.)

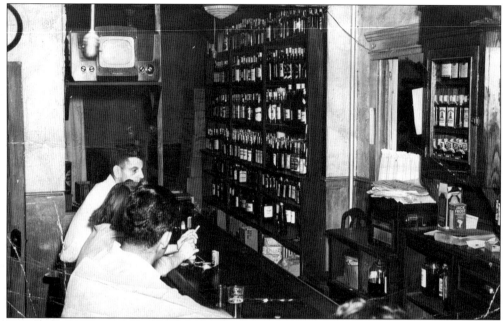

Dalina's Tavern got its first television set in 1948. In the days before every home had television, taverns and small bars were found throughout the area. The tavern served as a social gathering place where people could relax and get caught up on the news in the neighborhood. Workers from nearby factories would often cash their checks and talk with friends on payday before heading home. Weekend evenings brought couples out to have a drink or a bite to eat and to rest from the week's work. (Courtesy Pete Dalina.)

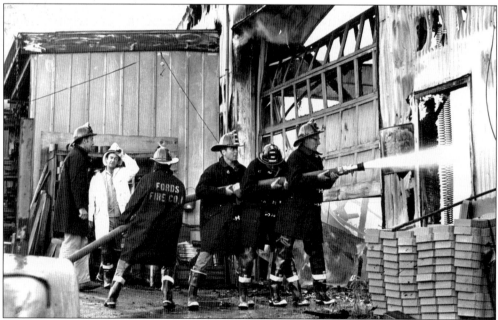

Fords Coal and Lumber Company, a longtime business in town, burned in 1970. Members of the Fords Fire Company No. 1 douse the last remnants of the blaze, which destroyed the property. (Courtesy Pete Dalina.)

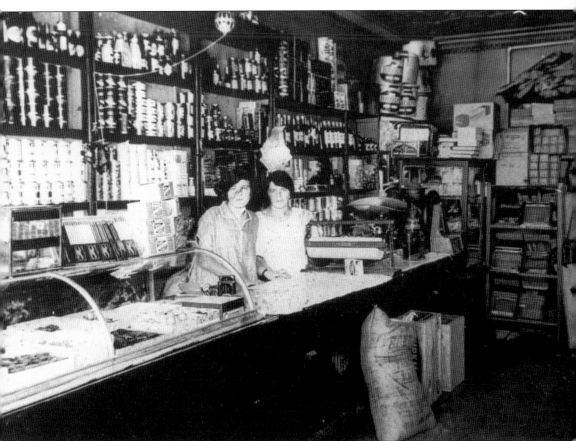

Mrs. Goldstein and her daughter Ann pose inside Goldstein's General Store, on New Brunswick Avenue, in 1915. The merchandise on display indicates the wide variety of items a general store carried—everything from umbrellas to chicken feed. A coffee grinder sits on the counter, and groceries line the shelves behind the two women. (Courtesy Woodbridge Public Library.)

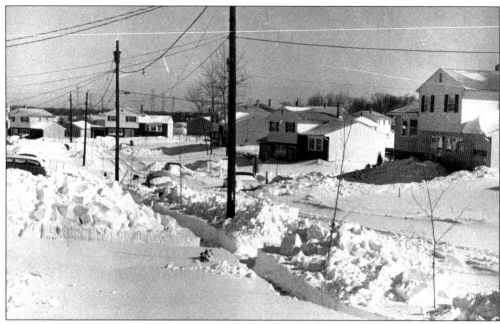

From the late 1950s through the early 1960s, Fords saw the construction of several housing developments. Men who had been in the armed forces during World War II were marrying and raising families. The suburban lifestyle took hold, with men having jobs in New York or Newark and commuting to new homes springing up in the suburbs. House prices ranged from $12,000 to the low $20,000s, depending on the development and lot size. Many of the families who moved here came from the more populated cities of New York or Jersey City and had never before owned homes. Shown during the winter of 1964 is a street in the Colonial Gardens development.

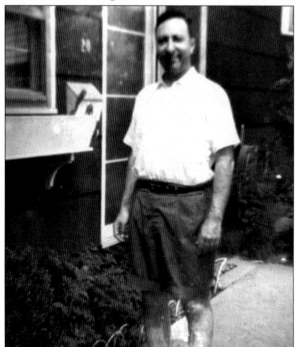

John De Amicis stands proudly in front of his new house in Colonial Gardens in 1961. De Amicis grew up in New York City, eventually went to work for the FBI in Newark, and bought this, his first and only house, in June 1960. Home buyers chose Fords because of the close proximity of major highways and train and air service, as well as the affordability of the properties available. Colonial Gardens was developed on the former picnic spot, Varady Grove.

Nikki Procopio leaves for her wedding from her home in the Lafayette Estates development in Fords. Her sister, Terry, helps with the train. These homes, like those in the Shorecrest and Colonial Gardens developments, were built in the popular split-level style of the time. (Courtesy Teresa Koebel.)

Another Lafayette Estates house in Fords serves as a backdrop for the Schneekloths and Koebels on Easter Sunday. The builder offered two different rooflines so that every house did not have to look identical to the one next door. (Courtesy Teresa Koebel.)

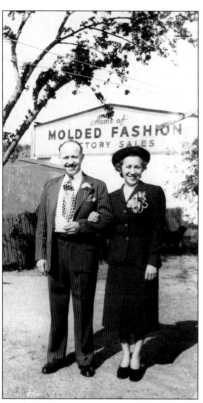

Molded Fashion, a factory that originally made hats, serves as the backdrop of this portrait of two Fords residents. (Courtesy Pete Dalina.)

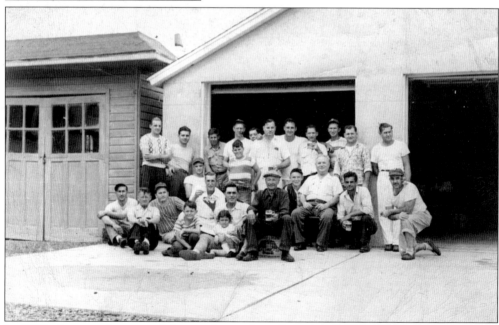

In 1953, the annual picnic of the employees from Dalina's Tavern was held on Crows Mill Road. Workers are assembled in front of the garages, which also belonged to the Dalina family. Often, owners lived over their businesses or right next door since they worked long hours and could be available whenever the business needed them. (Courtesy Pete Dalina.)

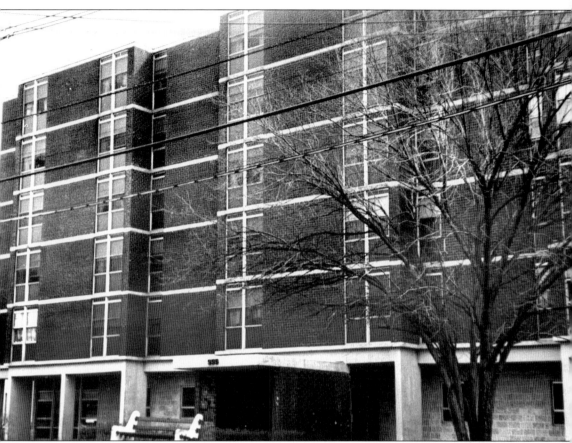

Olsen Towers, a senior citizens apartment building, was the first high rise built in downtown Fords. An increase in the number of seniors in the township brought to the forefront the need for housing that allows for independence without the responsibilities of caring for a single-family home. This photograph was taken in the late 1960s. (Courtesy Woodbridge Public Library.)

John and Mary Bodnar raised chickens, cows, and pigs in the backyard of their home, located on several acres in Fords. Bodnar worked in the clay mines. (Courtesy Stephen V. Kermondy.)

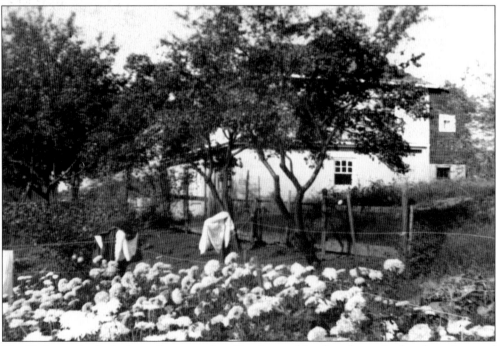

The Bodnars also had a large flower garden. Despite working long hours in the clay mines and doing chores on the farm, they found time to indulge their love of gardening. (Courtesy Stephen V. Kermondy.)

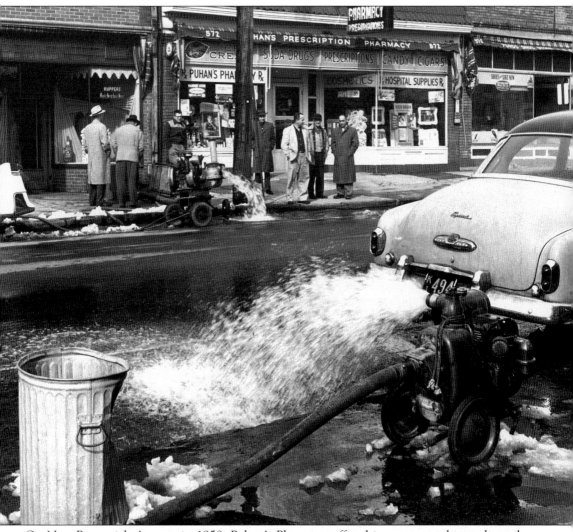

On New Brunswick Avenue in 1958, Puhan's Pharmacy offered ice cream, soda, candy, and cosmetics, besides filling prescriptions. Next door was a shoe-repair shop. The pump was draining the remnants of a winter storm from the stores' basements. (Courtesy Fords Fire Company No. 1.)

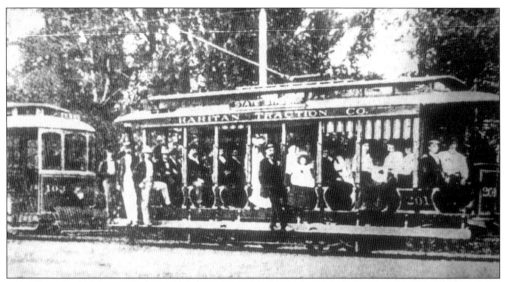

A trolley car heads to Fords on the line from Perth Amboy in the early 1900s. The cars were often open in the warmer months and enclosed during the winter. (Courtesy Woodbridge Public Library.)

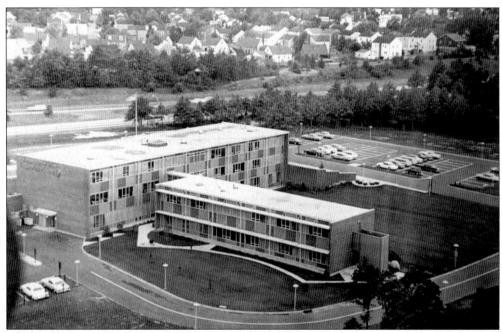

In 1945, the state of New Jersey designed the first landscaped highway. Called the Garden State Parkway, the road runs north and south for 173 miles, from the New York border to Cape May. The presence of the highway opened the area for more housing since people could commute more easily to New York. Located in Fords were not only an entrance and an exit but also the parkway administration building, shown in this 1963 photograph. (Courtesy Woodbridge Public Library.)

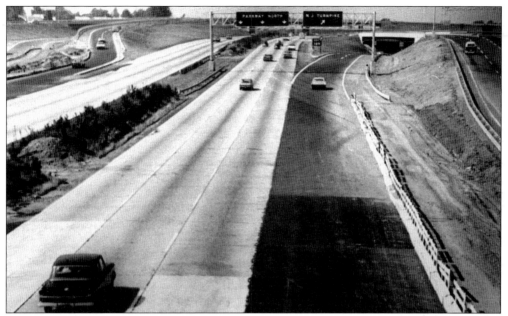

The Garden State Parkway intersects with the New Jersey Turnpike in Fords. The importance of the location of Woodbridge Township is evidenced by this. Being a crossroads for people and goods traveling between New York and points south was a significant element in the development of Woodbridge Township. That location continues to have importance to this day. (Courtesy Woodbridge Public Library.)

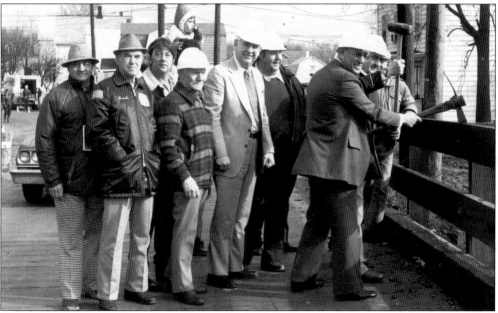

Local officials strike the symbolic first blows of the demolition of the Crows Mill Road bridge. For many years, the bridge that carried Crows Mill Road over the railroad tracks was a narrow wooden structure. Local residents used the span only because they needed to do so. Others would avoid it whenever possible. The bridge was finally demolished and replaced with a safer, newer-style bridge. (Courtesy Pete Dalina.)

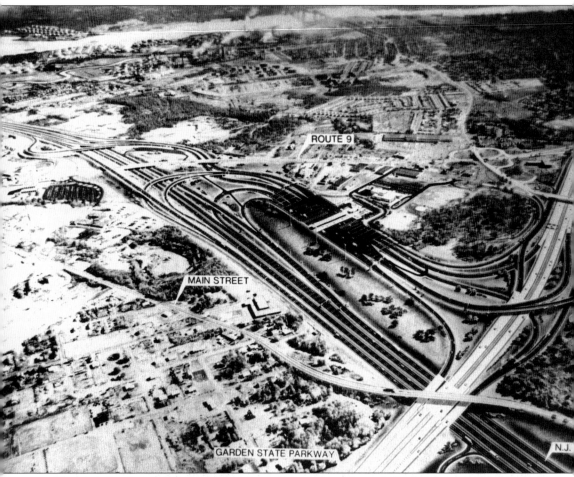

The interchange of all the major roads in the area runs through Fords. This aerial view shows the New Jersey Turnpike, the Garden State Parkway, and Route 9 (which runs into Route 1). In the background is the Outer Bridge, which crosses to Staten Island. In the upper right is the Kill, at the place where it empties into Raritan Bay. (Courtesy Woodbridge Public Library.)

Two
SCHOOLS, CHURCHES, AND LIBRARIES

The Fairfield Union School was located at the corner of King George Road and Hoy Avenue. The original building was destroyed by fire in 1861. A larger building was constructed and opened in 1862. Eventually, it was replaced by School No. 7. The photograph predates 1909, when a new four-room brick building was constructed. From left to right are Nellie Liddle, John Egan, and Clara Dunham. (Courtesy Woodbridge Public Library.)

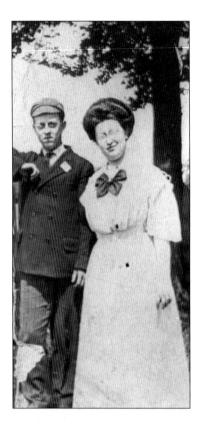

Pictured in June 1906 are Roy Mundy, a member of the graduating class of School No. 7, and principal Mae Taussig. (Courtesy Woodbridge Public Library.)

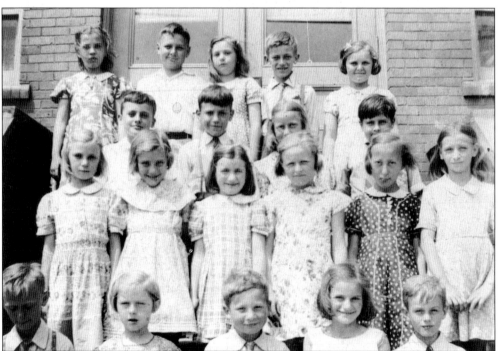

These Fords first-graders are shown in the late 1930s. (Courtesy Pete Dalina.)

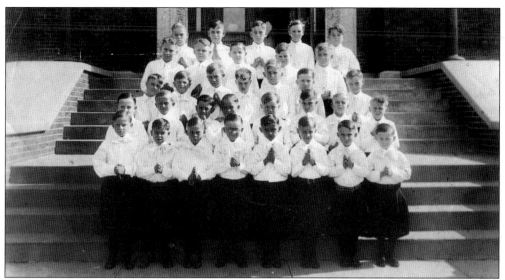

Shown are boys of the First Communion class of Our Lady of Peace Church in 1933. The boys are on the steps of the combination school and church building, which was constructed in the late 1920s for just under $100,000. (Courtesy Our Lady of Peace Church.)

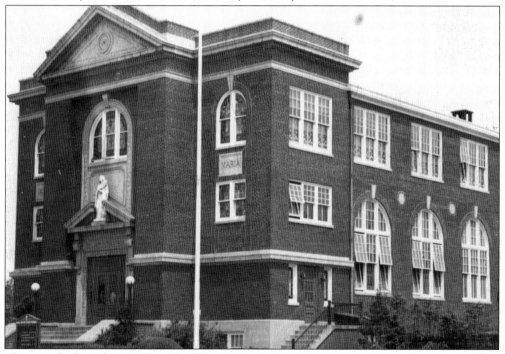

This was the first church-school building of Our Lady of Peace parish. Many Catholics came to Fords after the Civil War to work in the clay banks and brickyards. They would walk or go by wagon to St. James in Woodbridge or St. Mary's in Perth Amboy for worship. In 1919, Our Lady of Peace Church was established as a mission of St. Mary's. Mass was offered at the Fairfield Union School until a building owned by the Knights of Columbus was moved from the Raritan Arsenal to what is now the parking lot of the school annex. This building was affectionately known as the "Hut." (Courtesy Our Lady of Peace Church.)

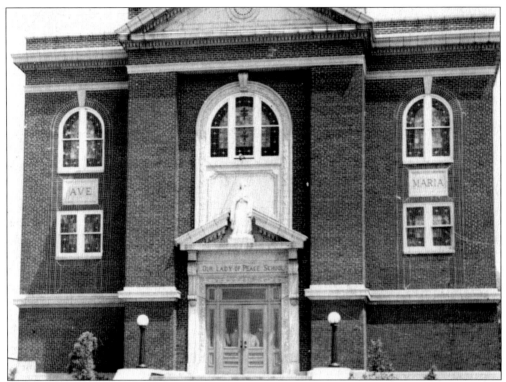

This front view of the church-school combination building shows the stained-glass windows, the Ave Maria carved into the facade, and the statue of Mary over the entrance. (Courtesy Our Lady of Peace Church.)

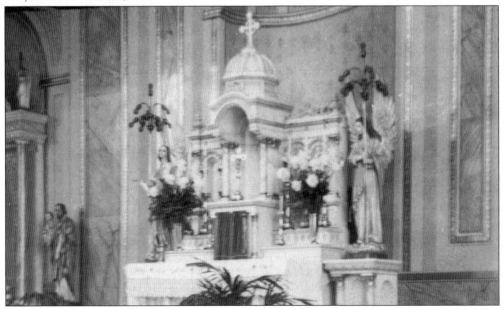

Shown is the altar inside the first church of Our Lady of Peace. Marble was used to adorn the sanctuary, as it was in many of the churches in the homelands of the first parishioners whose donations helped build the church. (Courtesy Our Lady of Peace Church.)

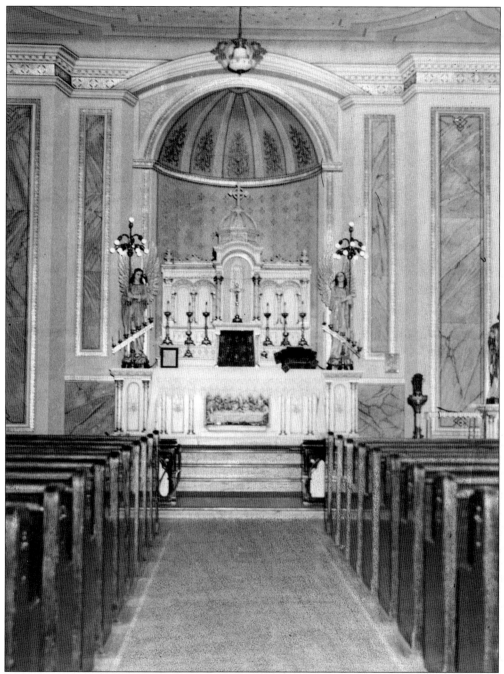

The combination school and church was finished in 1927. The school was staffed by the Sisters of Notre Dame, who were a semi-cloistered order of nuns. They occupied rooms on the second floor, which they used as a kitchen, chapel, and refectory. They used one of the classrooms as a dormitory. This view of the altar in the church part of the building shows the altar front piece and the electric candles, held aloft by two large angel statues. (Courtesy Our Lady of Peace Church.)

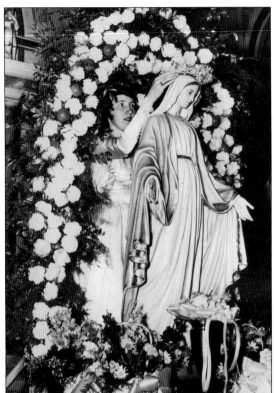

May crownings were very important events each year. A member of the girls' sodality would be chosen to be crowner. This crowning in 1952 shows how elaborately the shrine would be decorated. (Courtesy Our Lady of Peace Church.)

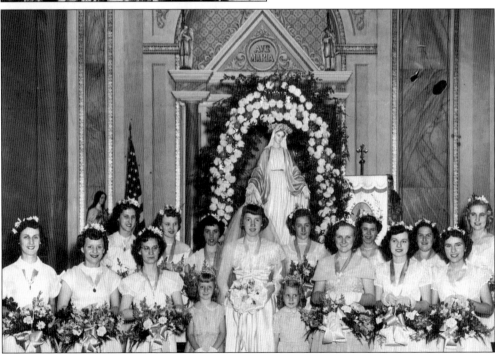

Eleanor Kocsik is the crowner in the center of this photograph of her entire retinue. The girls all wear their sodality medals. (Courtesy Our Lady of Peace Church.)

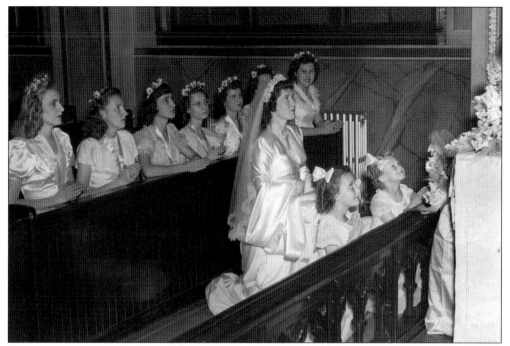

The May crownings were very important events in the life of the parish of Our Lady of Peace, as they were for many churches in the area. Often, the president of the sodality would be the crowner and the other officers her attendants. This 1949 photograph captures the crowner, Victoria Cosky, and her flower girls at prayer. (Courtesy Our Lady of Peace Church.)

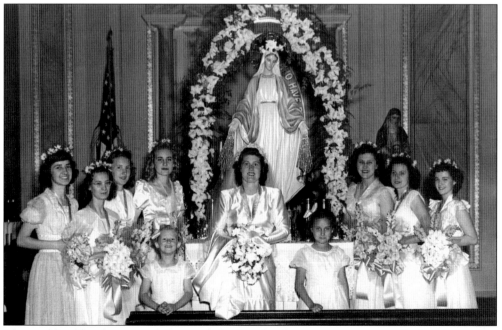

The weddinglike dresses and flowers helped make the event even more festive than other religious services. Here, Victoria Cosky and her attendants pose in front of the statue after the crowning ceremony. (Courtesy Our Lady of Peace Church.)

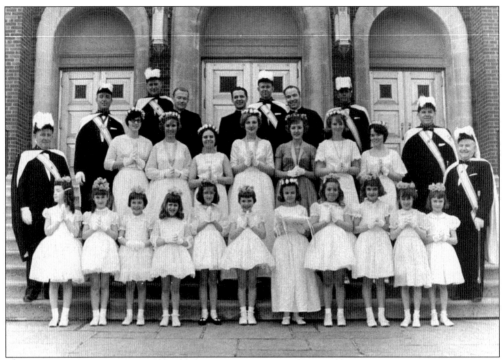

The May crowning included the Knights of Columbus as well as the sodality. Often, these men would participate in crownings throughout the area, especially if the local church did not have its own chapter. Their plumed hats and drawn swords added to the serious nature of the occasion. These pictures were taken in 1966 and 1967 inside the school auditorium and outside the current church. (Courtesy Our Lady of Peace Church.)

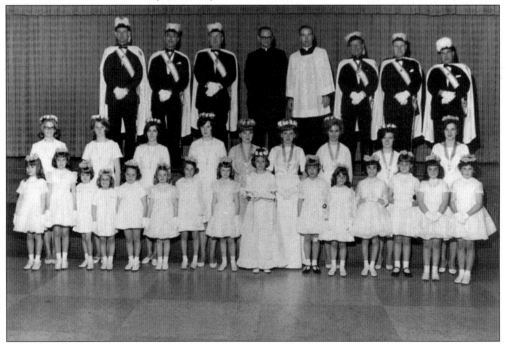

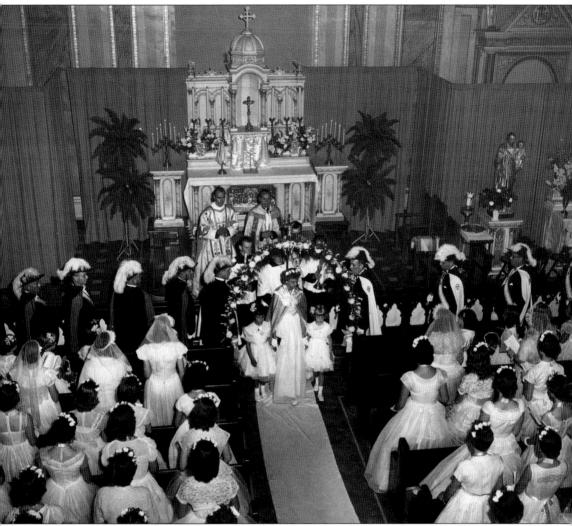

Regional crowning services were held in the area, as well as in individual churches. Usually one crowner was chosen to have that same honor on a regional level, and all of her sodality members would join with the other churches' groups to participate. Hundreds of people would attend these events, which were often held in Water Stadium in Perth Amboy to accommodate the crowds. Having a daughter chosen to be the crowner was considered an honor and could be as important to coordinate as a wedding. (Courtesy Our Lady of Peace Church.)

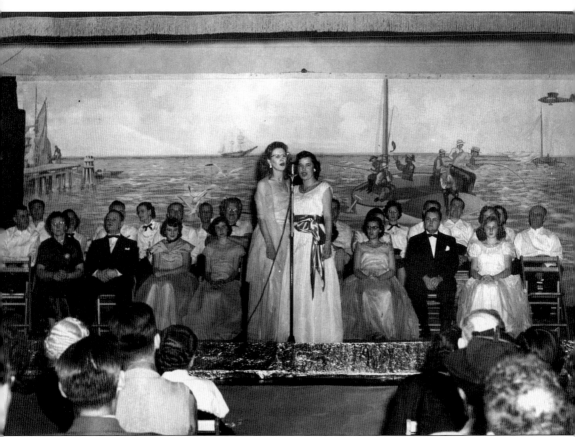

The church served as a social gathering place as well as the place to worship. Often, the programs that were presented were used as fund-raisers. Besides that purpose, they also gave people a source of entertainment before television dominated the evenings. This parish show took place during the 1950s. (Courtesy Our Lady of Peace Church.)

In the early 1950s, Our Lady of Peace was bursting at the seams. In 1951, the parish had added an annex building with six classrooms and an auditorium that was also used for Mass on Sundays. The church still needed more room as the baby boom swelled the numbers of children in the school to almost 1,000. In 1953, Our Lady of Peace decided to build a new church next to the existing one and use the first building exclusively as a school. (Courtesy Our Lady of Peace Church.)

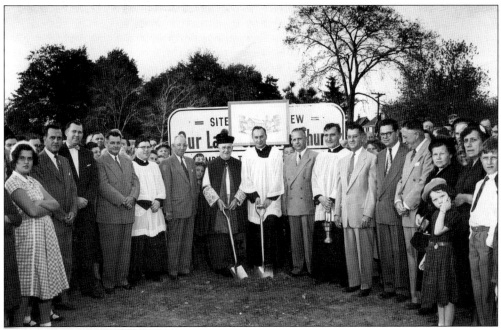

Msgr. John E. Grimes leads off with the first shovelful of soil at the groundbreaking ceremony, which took place on October 4, 1953. (Courtesy Our Lady of Peace Church.)

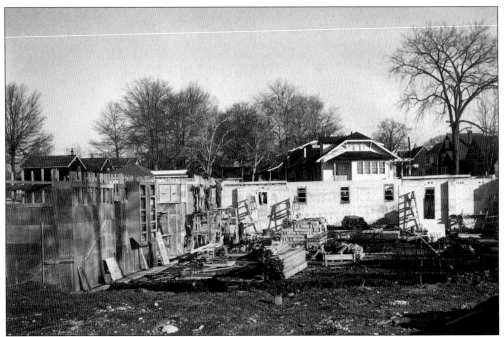

Work on the foundation for the new church continued through the winter of 1953. The building was designed to seat 1,060 people. (Courtesy Our Lady of Peace Church.)

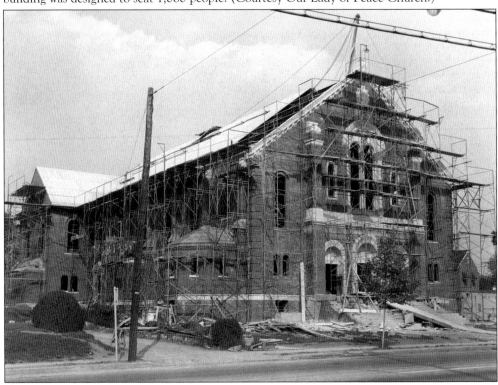

A year after the groundbreaking, the new church starts to take shape. The site is the corner of New Brunswick and Ford Avenues. (Courtesy Our Lady of Peace Church.)

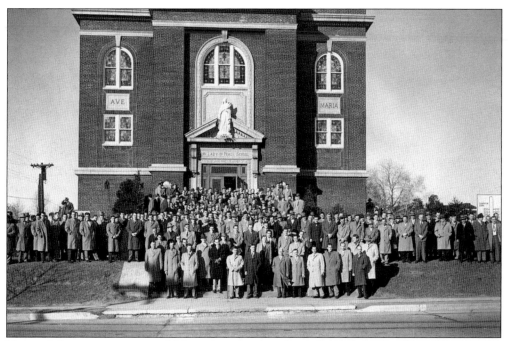

None of the construction could have happened without the dedication of parishioners who worked on raising the funds needed to finance the project and the generous donations of their fellow parishioners who supported it. (Courtesy Our Lady of Peace Church.)

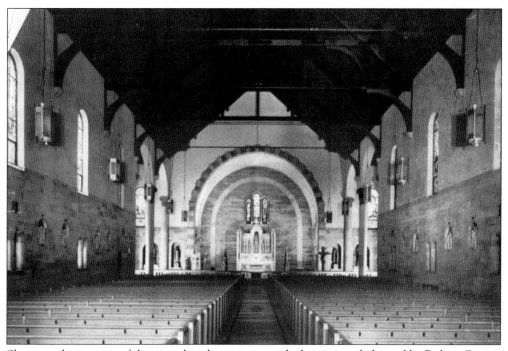

Shown is the interior of the new church as it appeared when it was dedicated by Bishop George W. Ahr on August 14, 1955. The wooden ceiling and the stained-glass windows behind the altar were removed during later renovations. (Courtesy Our Lady of Peace Church.)

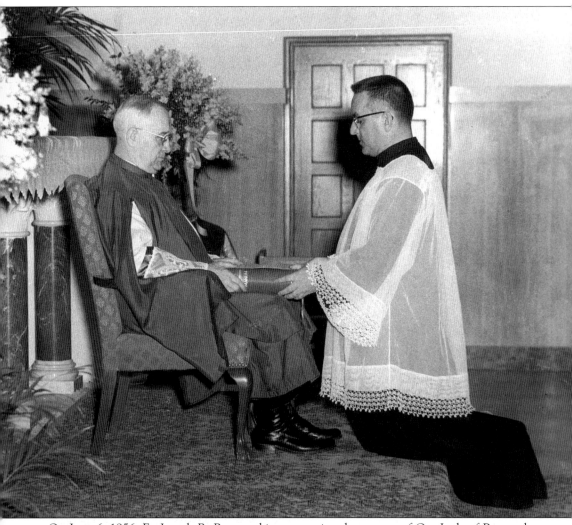

On June 6, 1956, Fr. Joseph R. Brzozowski was appointed as pastor of Our Lady of Peace, thus beginning a long and busy time for the parish. This photograph shows Father Brzozowski kneeling in front of the presider during his installation ceremony. (Courtesy Our Lady of Peace Church.)

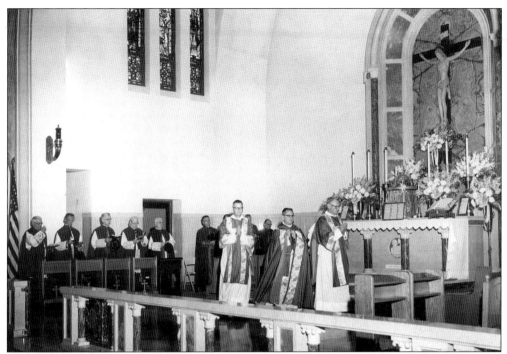

In 1962, Father Brzozowski celebrated his 25th anniversary as a priest of the Trenton Diocese. (Courtesy Our Lady of Peace Church.)

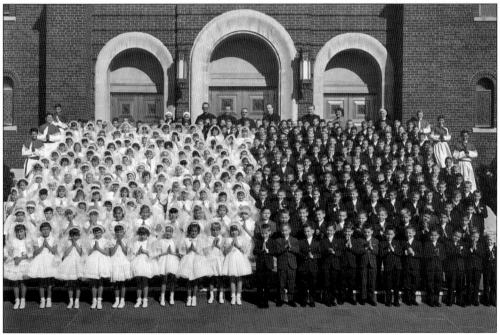

Members of the First Communion class pose in front of the new church in 1965. Father Brzozowski is the top row. The school's enrollment had swelled to an all-time high of 1,311 pupils, and the number of families registered in the parish had reached nearly 3,000, making Our Lady of Peace one of the largest parishes in the area. (Courtesy Our Lady of Peace Church.)

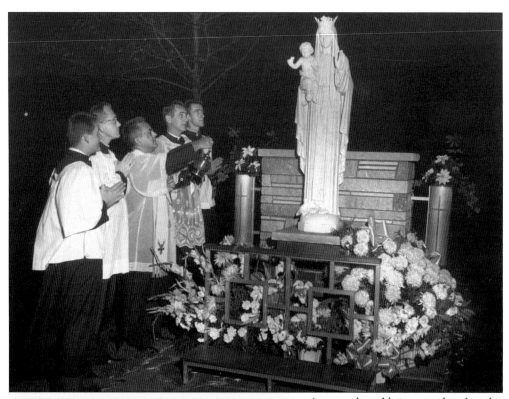

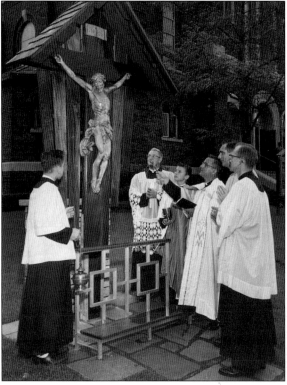

Among the additions to the church grounds made during Father Brzozowski's early years in the parish were two outdoor shrines in the front of the church. One was dedicated to Mary, and the other was a crucifixion. These followed the European traditions of roadside shrines where passersby could stop for a short moment to meditate and pray. Situated on the corner of the front churchyard, they were visible to everyone driving down New Brunswick Avenue. (Courtesy Our Lady of Peace Church.)

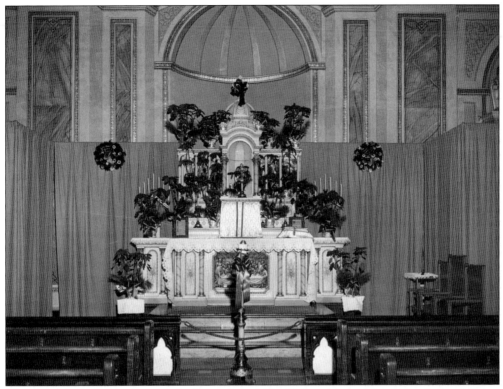

This January 1, 1954 photograph shows the inside of the old church of Our Lady of Peace decorated for the Christmas season. (Courtesy Our Lady of Peace Church.)

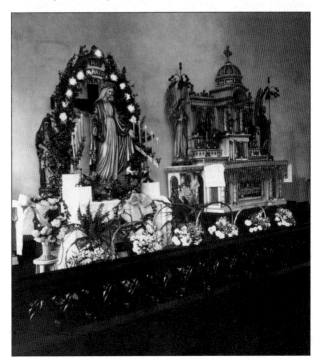

Shown is the altar area of the first church, decorated during the month of May, right after one of the May crownings. (Courtesy Our Lady of Peace Church.)

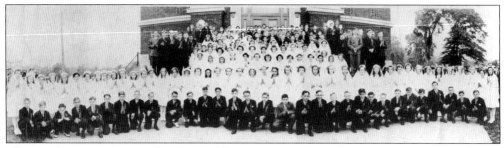

The Confirmation class can barely fit across the front of the first church building, which also housed the school when this photograph was taken in 1941. (Courtesy Our Lady of Peace Church.)

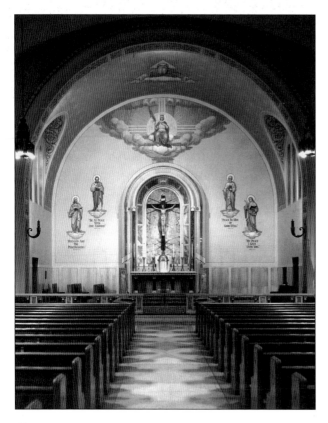

The new church underwent decorative changes in the early 1970s, when a mural of Our Lady of Peace was placed over the altar and the four evangelists were placed to the sides. The ceiling throughout the church was treated with various decorative motifs, and the sanctuary's curved ceiling area saw the addition of God the Father in a field of stars. The decoration remains this way today. (Courtesy Our Lady of Peace Church.)

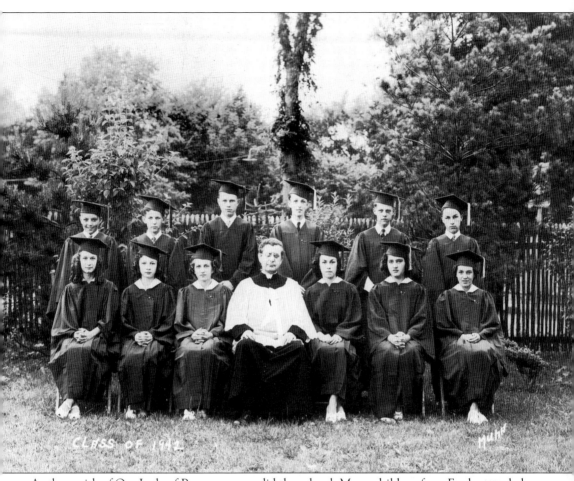

As the parish of Our Lady of Peace grew, so did the school. Many children from Fords attended the school, and many more always seemed to be on a waiting list. Shown is the Class of 1942 sitting for its graduation picture. From left to right are the following: (front row) Anna Marie Zaleski, Marie ?, Anna Trello, Father Ketter, Irene Jugan, Rose Kalman, and Dorothy Kovacs; (back row) Frank Galya, Richard Gallagher, Frank Kaminsky, Joseph Germain, Lou Farkas, and Bill Jugan. (Courtesy Our Lady of Peace Church.)

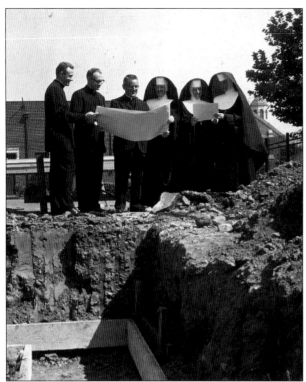

The Sisters of St. Joseph took over the teaching responsibilities at Our Lady of Peace School in 1940. They originally slept in two vacant classrooms. In 1942, a house was purchased on Wolff Avenue to serve as a temporary convent. A new convent was finally constructed in 1962 for the very patient sisters. Fr. Joseph R. Brzozowski, some of the sisters, and two priests of the parish look over the plans for the new building at the site. (Courtesy Our Lady of Peace Church.)

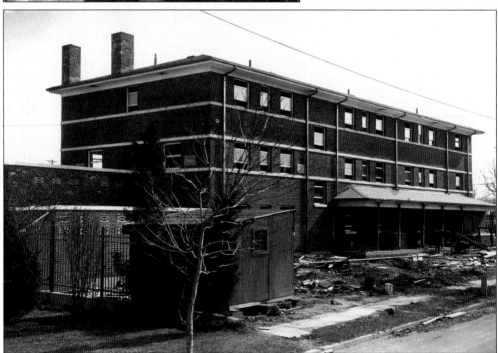

Shown is the convent under construction in 1962. Finally the sisters were going to have enough room to accommodate the numbers required to staff a school that was reaching for an enrollment high of more than 1,300 pupils. (Courtesy Our Lady of Peace Church.)

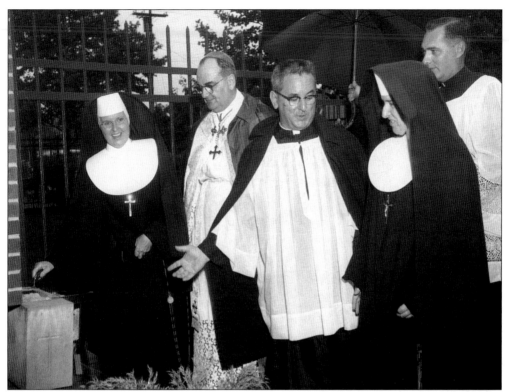

Father Brzozowski shows school principal Sr. Teresa Catherine the cornerstone of the new convent. In the background is Bishop George W. Ahr. (Courtesy Our Lady of Peace Church.)

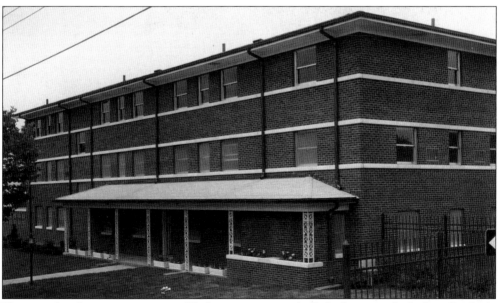

The completed convent was soon filled to capacity, as the baby boomers flocked to Our Lady of Peace School. The nuns often found themselves teaching classes of more than 40 students. (Courtesy Our Lady of Peace Church.)

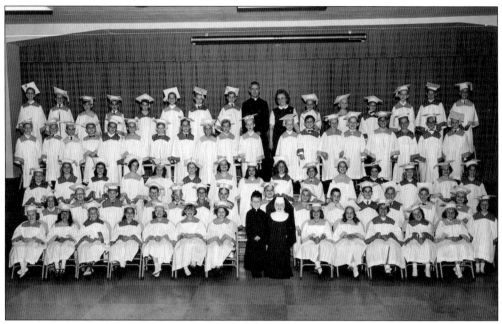

Our Lady of Peace kindergarten graduation in 1964 includes 77 students who were in the two classes. It was the custom at the time to dress one of the boys as a miniature priest and one of the girls as a tiny sister. (Courtesy Our Lady of Peace Church.)

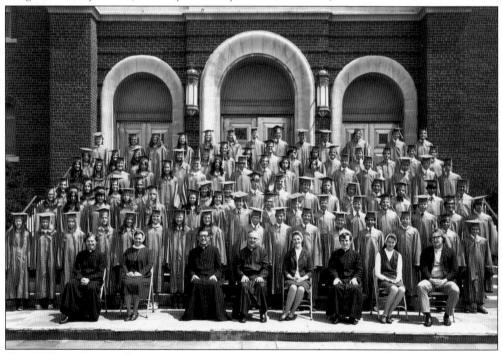

This 1972 graduation photograph shows that the numbers are not as high as they were in the 1960s, but the school still played an important role in the education of many Fords children. This group is pictured in front of the church with the pastor, principal, associates, and their teachers. (Courtesy Our Lady of Peace Church.)

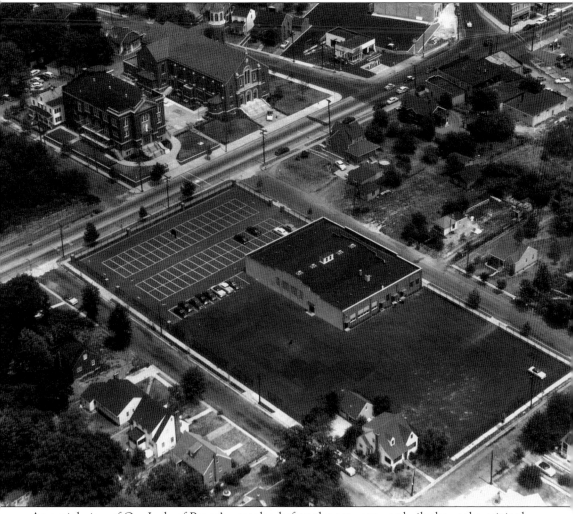

An aerial view of Our Lady of Peace's complex before the convent was built shows the original church-school building, the new church, and the school annex across New Brunswick Avenue. (Courtesy Our Lady of Peace Church.)

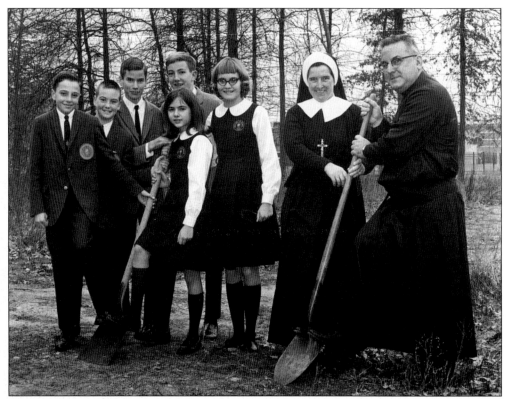

In December 1966, the seventh- and eighth-grade class presidents joined the principal, Sr. Teresa Catherine, and Fr. Joseph R. Brzozowski as they broke ground for another school annex, which was designed to have a gymnasium in it. (Courtesy Our Lady of Peace Church.)

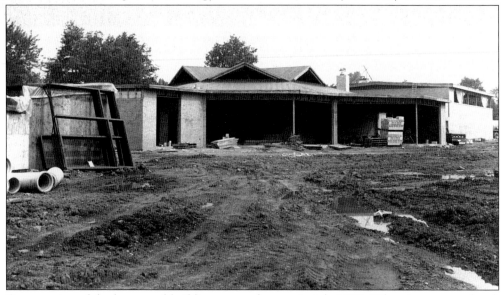

Construction of the hexagonal building was under way in July 1967. When it was completed, the building replaced the older annex, which became a parish center. (Courtesy Our Lady of Peace Church.)

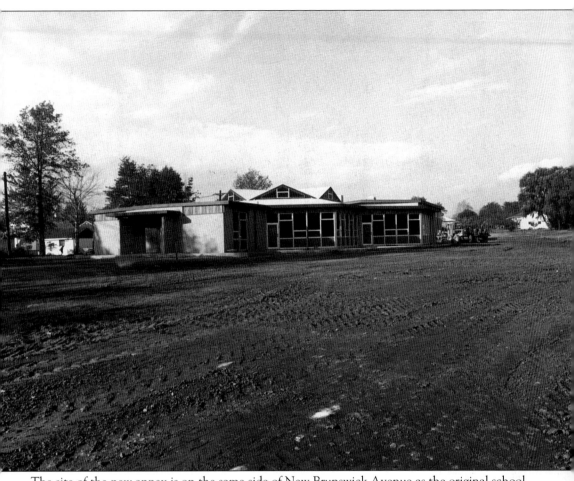

The site of the new annex is on the same side of New Brunswick Avenue as the original school building, thus adding to the safety of pupils who no longer had to cross the busy street to move between the buildings. (Courtesy Our Lady of Peace Church.)

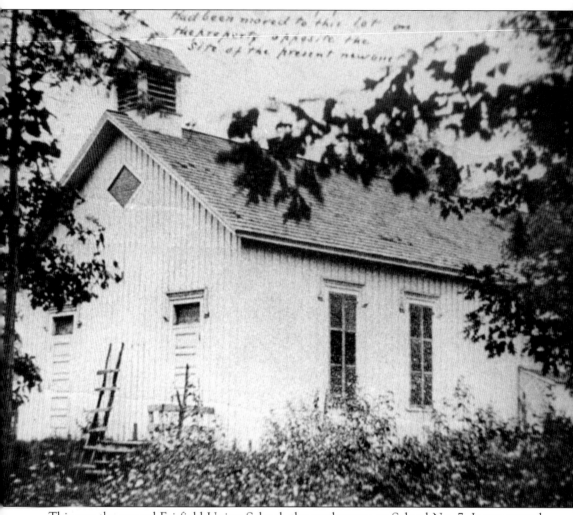

This was the second Fairfield Union School, the predecessor to School No. 7. It was moved from its first site to a lot across the street so that School No. 7 could be built in its place. (Courtesy Woodbridge Public Library.)

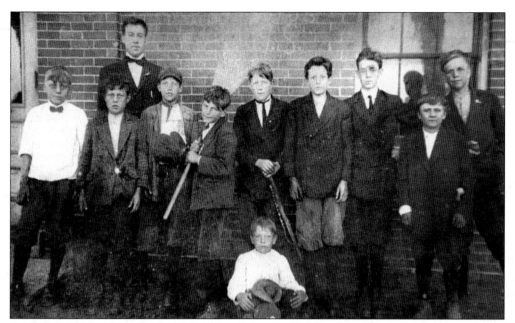

Fords School No. 7 was built on the site of the original Fairfield Union School. It provided youngsters with an education and a chance to compete in sports before the advent of organized teams and the Little League system. Members of the 1912 team are, from left to right, John Dixon, Oscar Sundquist, Clifford M. Dunham, Albert Kistrup, Martin Smith, Cyrus Dunham, Eugene Geiling, Raymond Wilson, and Neils Lauritzen. Also shown are mascot Peter Peterson (front) and teacher Mr. Follensby (back). (Courtesy Woodbridge Public Library.)

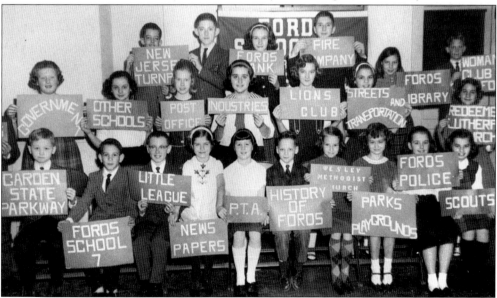

These students were members of the Junior Historians at School No. 7 in 1964, when the township celebrated its 300th anniversary. They attended class at the site of one of the first schools in the area and took pride in the history of their community. They hold signs designating the important elements of the community that they were studying in connection with the anniversary. (Courtesy Woodbridge Public Library.)

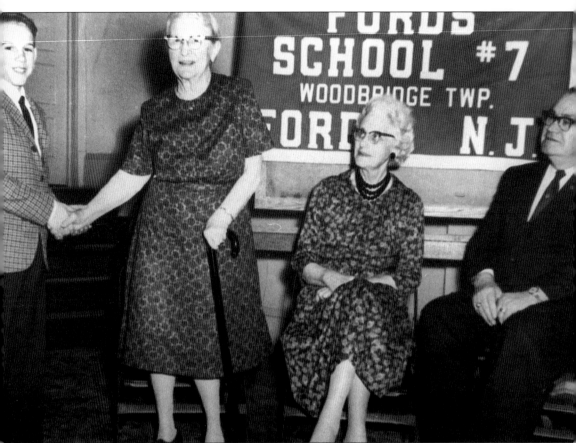

To learn more about the past that they were studying, students got to meet some of the people who had lived in and experienced the early times. Philip Mingin greets Mae Taussig, the former teacher and principal of the Fairfield Union School, during an assembly on the history of the township at School No. 7. Georgiana Cronce and John Egan, a former police chief, are also pictured. Both had been pupils taught by Mae Taussig. (Courtesy Woodbridge Public Library.)

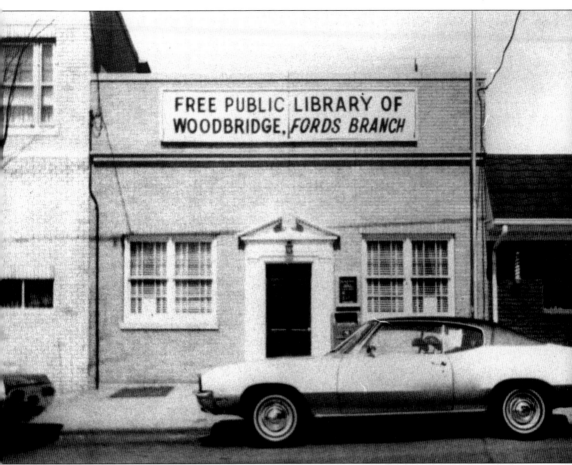

FREE PUBLIC LIBRARY OF
WOODBRIDGE, *FORDS BRANCH*

The main goal of the Fords Woman's Club, which was founded in 1920, was to bring library services to the community. In 1924, the club started a free public library in a rented space and used volunteers to staff it. In 1940, the club moved to a building, which was donated by Our Redeemer Lutheran Church in Fords. The club operated its library there until 1964, when the municipal library was inaugurated. The club then donated furnishings and 10,000 books to the new Fords Branch Library. (Courtesy Woodbridge Public Library.)

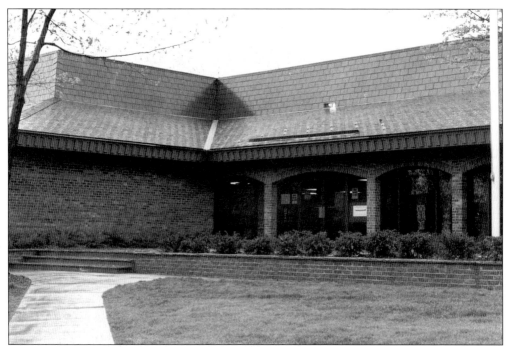

The new Fords Branch Library was constructed on Ford Avenue. Its larger quarters and connection to the municipal system offered improved service to the reading public. Shown is the exterior of the new library. (Courtesy Woodbridge Public Library.)

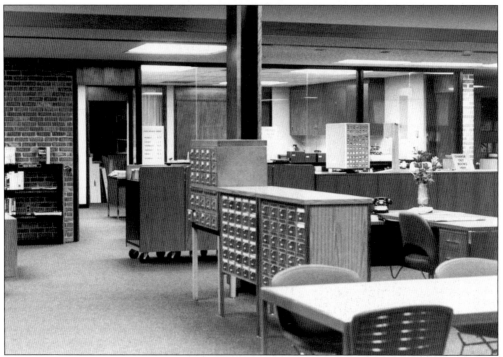

The interior of the new Fords Branch Library shows the most up-to-date facilities available in 1972. (Courtesy Woodbridge Public Library.)

First Presbyterian Church, on Hoy Avenue in Fords, was started just after the end of World War I. At that time, services for Slovak Presbyterians were held in Perth Amboy. Many Slovaks had been drawn to the area, along with other eastern Europeans, by the work available in connection with the clay industry. In 1924, the Slovak families from Fords voted to build their own chapel, which would be closer and more convenient. The building took great sacrifice from the small church's members, but the cornerstone was laid in 1925 and the church dedicated in May 1926. These pictures show Elizabeth and Michael Petruski outside the church following their wedding. Over the doors are the words Slovak Presbyterian Church. (Courtesy Rita Bihary.)

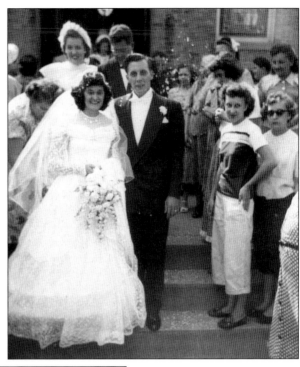

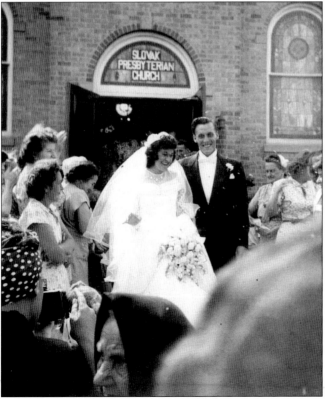

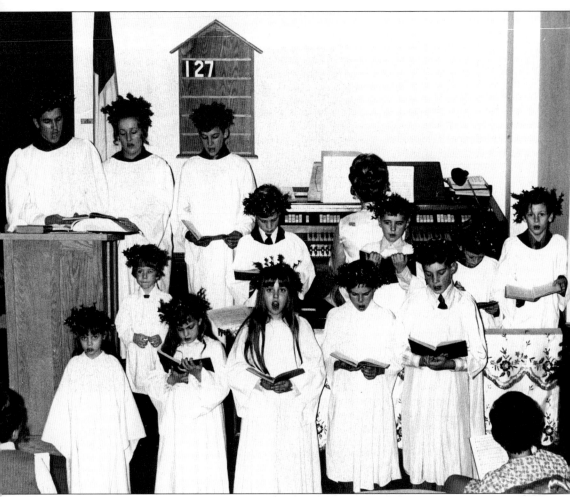

Services at the Slovak Presbyterian Church were conducted in Slovak until 1962, except for certain special occasions when they were bilingual. In July 1965, the congregation chose the name First Presbyterian Church as more of its members came from other ethnic backgrounds and the numbers of immigrants diminished. The sanctuary was also updated at that time. Shown are children performing a Christmas Eve program in 1971. From left to right are the following: (front row) Christi Benitz, Barbara Stueber, Ruth Ann Stueber, Robert Mako, and Keith Dante; (middle row) Todd Gerba, Ronald Bihary, Robert Studva, Kenneth Bihary, and Gerald Dante; (back row) Andrew John Mako, Janet Misak, and Glenn Mako. The organist is unidentified. (Courtesy Rita Bihary.)

Our Redeemer Lutheran Church began in Fords in 1909, when a small chapel was built on the corner of First and Fourth Streets. The land was donated by Neil Skov. His brother, Rev. V.B. Skov, conducted Sunday school and occasional services there. The chapel was enlarged in 1919, and an addition was put on for the growing Sunday school in 1920. The addition also held a kitchen. The old chapel finally became too small and was donated to the Woman's Club of Fords for use as a library. The new structure was begun in October 1939 and dedicated on May 12, 1940. In 1965, the building was enlarged to include space for the Lutheran Education Center. A happy couple stands at the doors of the church after their wedding. (Courtesy Teresa Koebel.)

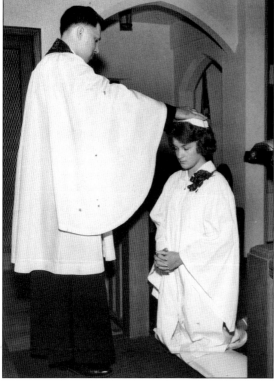

Rev. Eldon R. Stohs confirms Teresa Procopio in Our Redeemer Lutheran Church in 1963. Reverend Stohs led the congregation until his untimely death in an automobile accident a few years later. (Courtesy Teresa Koebel.)

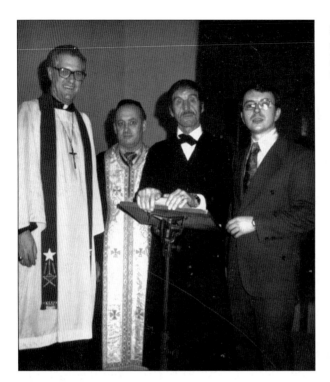

Shown is the installation of elders ceremony at Our Redeemer Lutheran Church in 1970. (Courtesy Teresa Koebel.)

Holiday parties and dinners during the year were often sponsored by organizations in the church for fund-raising and social purposes. This Christmas gathering was held in the church hall. (Courtesy Teresa Koebel.)

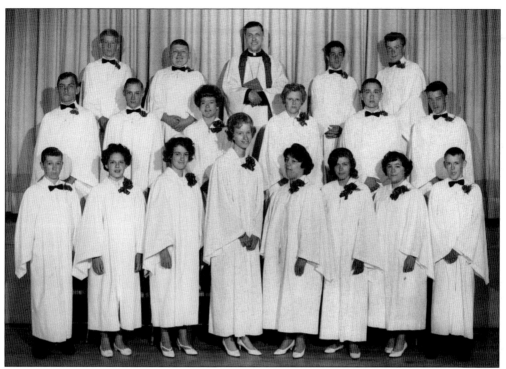

The Confirmation class poses with Rev. Eldon R. Stohs following the ceremony in 1963. (Courtesy Teresa Koebel.)

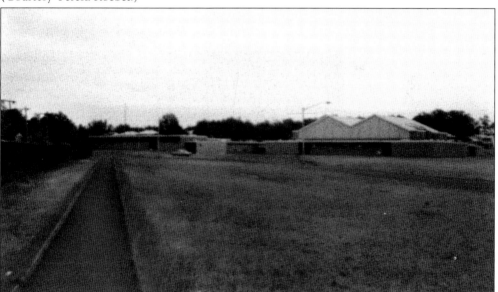

Fords Junior High School was opened in 1960 to accommodate grades seven, eight, and nine from School No. 7, School No. 14, and Lafayette Estates School No. 25 in Fords, as well as students from Menlo Park Terrace, Keasbey, and Hopelawn. The junior high school had 1,200 students in 1964. It was built on one level, making it different from the multistoried schools of the past. It was built in a section of Fords that the locals called "New Fords" because of the newer housing developments built there. (Courtesy Teresa Koebel.)

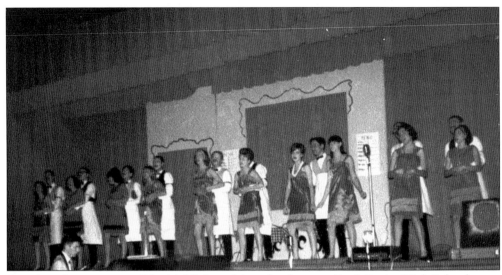

A variety show was one of the highlights of the school year at Fords Junior High School.

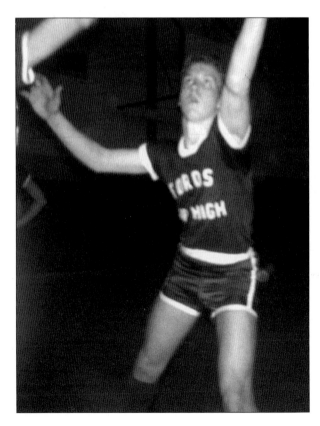

Student athlete Joe Croasdale plays basketball in the gym of Fords Junior High School in 1965. (Courtesy Teresa Koebel.)

Three
A HISTORY OF SERVICE

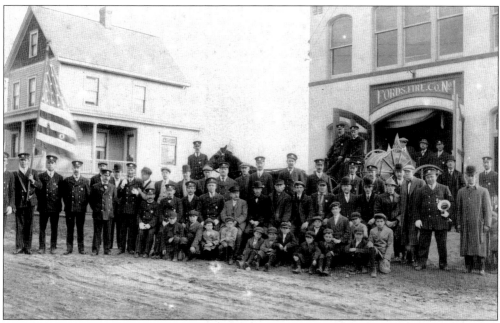

On a late summer evening, September 19, 1911, 22 men gathered at Mel Clum's General Store in Fords. The men discussed the expected construction of a factory in town and the fire that had occurred months earlier at the Triangle Factory in New York, claiming more than 140 lives. These men were to become the charter members of Fords Fire Company No. 1. They talked about possible locations for a firehouse and how to finance it. They drew up and signed a certificate of incorporation, which was filed in the county clerk's office on September 21, 1911. They pooled their own funds to purchase a piece of property from the Jensens, who took $60 off the asking price since it was for a good cause. The lot was purchased for $125. By August 1912, the new firehouse was in service. Shown is the first horse-drawn vehicle the company acquired, after using a hand-pulled chemical truck for the first year. They bought this horse cart from the City of Perth Amboy for the sum of $10. (Courtesy Fords Fire Company No. 1.)

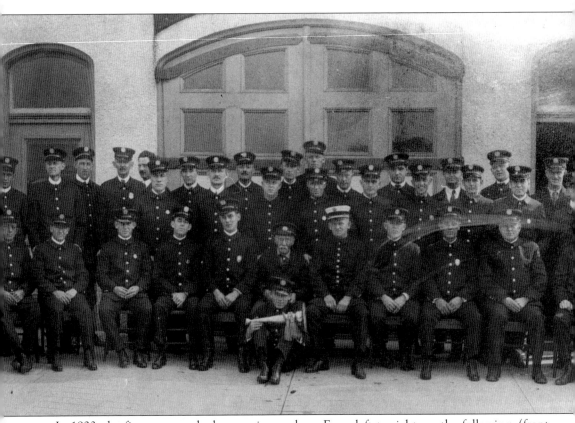

In 1923, the fire company had grown in numbers. From left to right are the following: (front row) P. Hansen, W. Ernst, S. Garrick, "Muf" Mills, W. Rodner, "Pop" More, B. Jensen, H. Thompson, C. Lund, W. Hoy, A. Bagger, W. Jensen, M. Hansen, and W. Hellegaard (with trumpet); (middle row) A. Olsen, H. Andersen, M. Sindet, R. Predmore, A. Madsen, "Pop" Rodner, J. Jogan, C. Lund, R. Liddle, G. Murdock, A. Christensen, H. Petersen, L. Hanson, A. Hirner, L. Ferbel, G. Geiling, F. Olsen, W. Olsen, and W. Lybeck; (back row) C. Kish, G. Frick, A. Overgaard, H. Johansen, C. Sundquist, A. Jensen, H. Sloan, W. Liddle, A. Lind, H. Madison, and G. Balint. (Courtesy Fords Fire Company No. 1.)

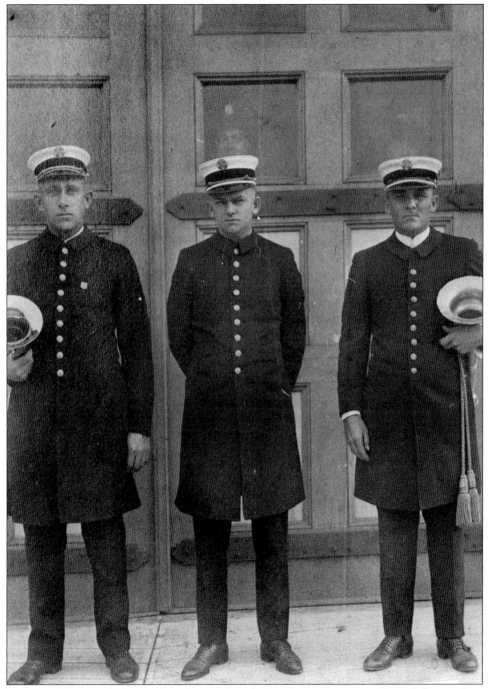

This 1923 photograph shows the officers of Fords Fire Company No. 1. From left to right are A. Olsen, B. Jensen, and W. Lybeck. (Courtesy Fords Fire Company No. 1.)

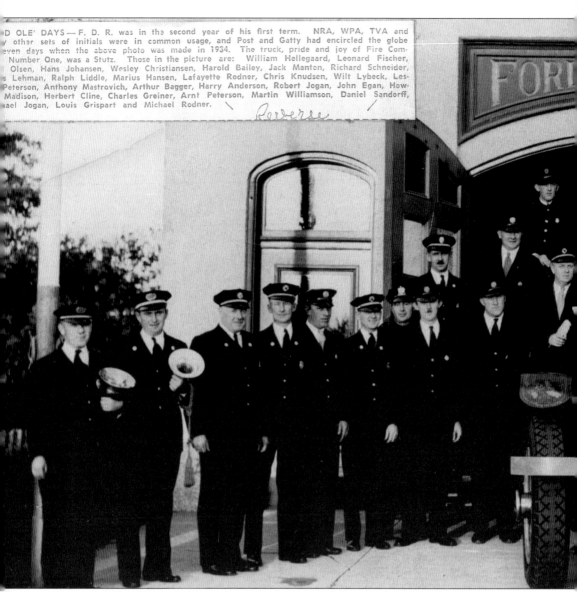

The men of Fords Fire Company No. 1 gather around their pride and joy, a Stutz fire truck, in 1934. Note the trumpet, which was an important piece of equipment in the days before call boxes, other alarm systems, and radios. It was actually used to amplify the voice of the fire

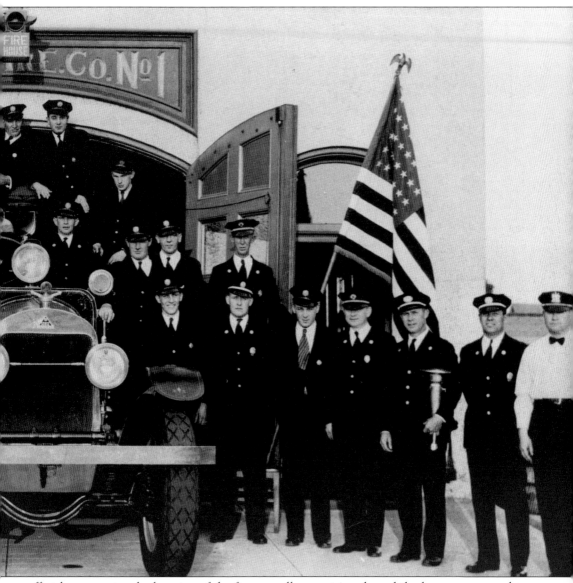

official announcing the location of the fire, as well as to give orders while the men were at the scene. Today, it proudly serves as a symbol of the dedication of these early civic-minded souls. (Courtesy Fords Fire Company No. 1.)

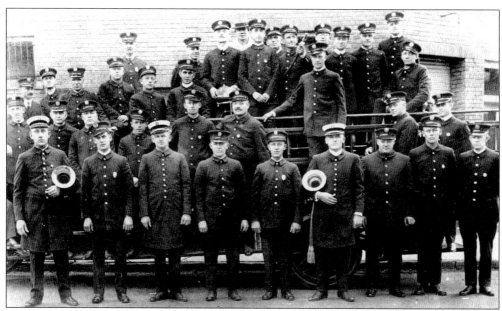

Members of the fire company pose with their truck, a brand-new Seldon, in 1936. From left to right are the following: (front row) H. Anderson, W. Dunham, W. Hellegaard, C. Blanchard, L. Grispart, C. Lund, H. Dunham, C.W. Lund, H. Johansen, R. Liddle, W. Lybeck, H. Cline, A. Horvath, M. Jorgan, H. Bally, and L. Rodner; (back row) H. Madison, J. Carmondy, C.J. Cavallito, H. Jensen, A. Sindet, G. Jorgan, P. Smalley, A. Petersen, H. Hanson, E. Williamsen, M. Williamsen, L. Blanchard, H. Sharp, G. Lehman, L. Petersen, and B. Jensen. The driver is M. Hansen. (Courtesy Fords Fire Company No. 1.)

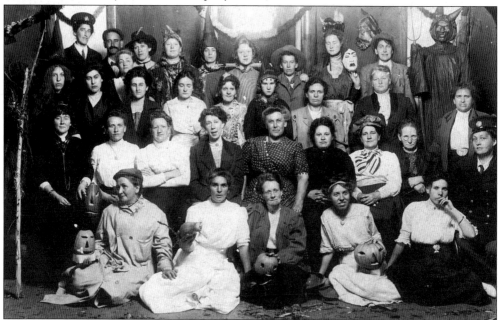

Although Fords Fire Company No. 1 never had a ladies auxiliary, the female family members were always involved in social activities related to the firehouse. These women take part in a Halloween event in the 1920s. (Courtesy Fords Fire Company No. 1.)

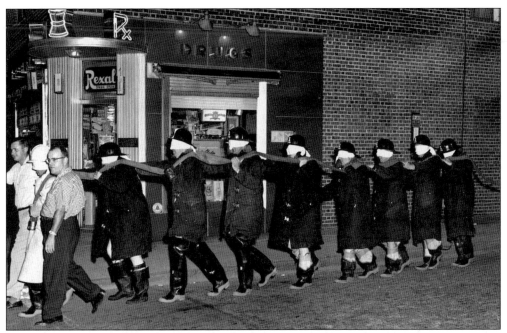

New volunteers to the fire department spend a lot of time learning about firefighting techniques and fire prevention. On their one-year anniversary, the newest class was traditionally led by older members through the streets blindfolded. Shown are the men from the 1956 group. (Courtesy Fords Fire Company No. 1.)

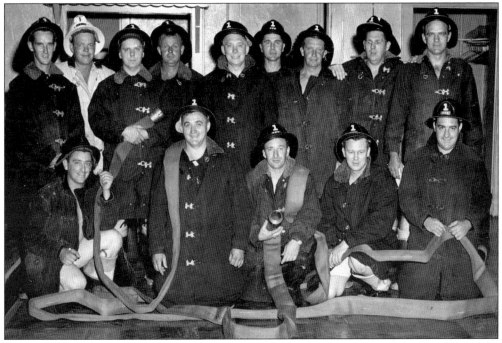

Following their initiation walk through Fords, the 1956 group returns to the firehouse. Knowing that the walk would happen each year, residents of the area often gathered on the sidewalks to watch and cheer the men on. (Courtesy Fords Fire Company No. 1.)

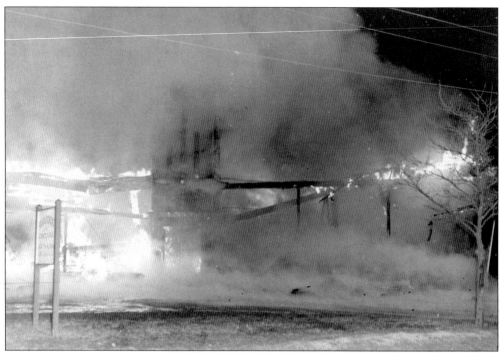

During the early days of Fords, when most of the inhabitants lived on farms, the fire department did not require very much in the way of equipment. However, with the increase in homes and factories, the department needed to be able to fight industrial blazes like this one. (Courtesy Fords Fire Company No. 1.)

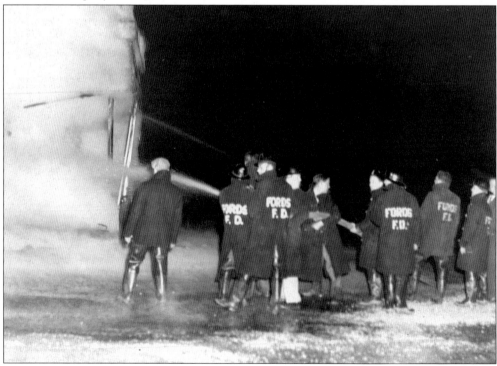

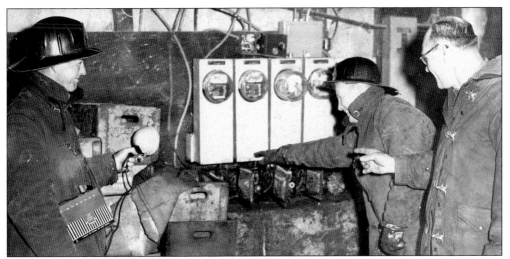

These photographs show the aftermath of a 1957 fire involving commercial property. Members of the fire department work in the flooded basement of the structure. (Courtesy Fords Fire Company No. 1.)

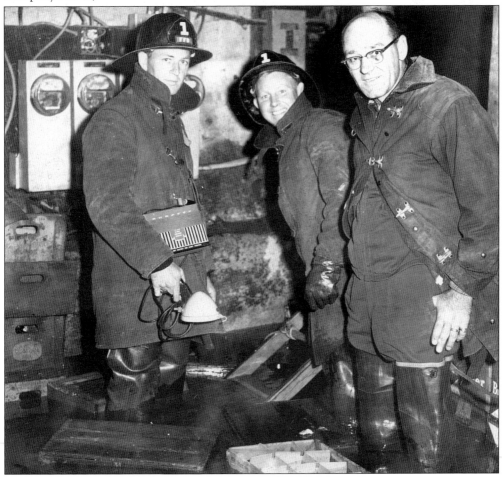

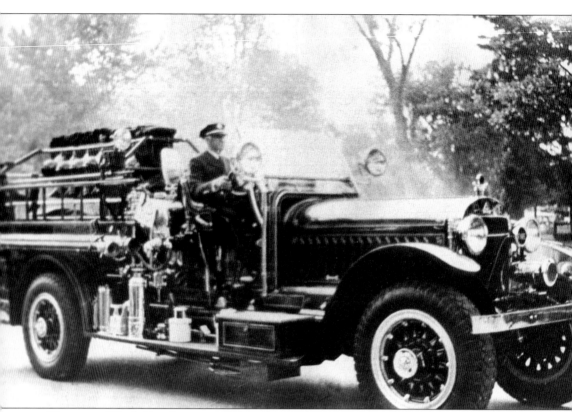

The men of Fords Fire Company No. 1 always took pride in their vehicles. The Stutz is being driven by Marius Hansen. (Courtesy Fords Fire Company No. 1.)

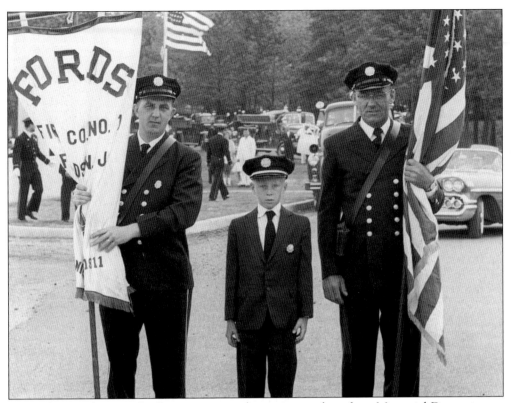

Throughout its history, the fire company took part in parades—from Memorial Day events to the annual Little League parade. Shown are two members and their mascot during one parade from the early 1960s. (Courtesy Fords Fire Company No. 1.)

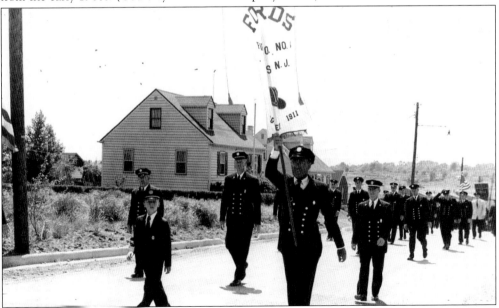

Part of the fire company contingent marches proudly during the parade. (Courtesy Fords Fire Company No. 1.)

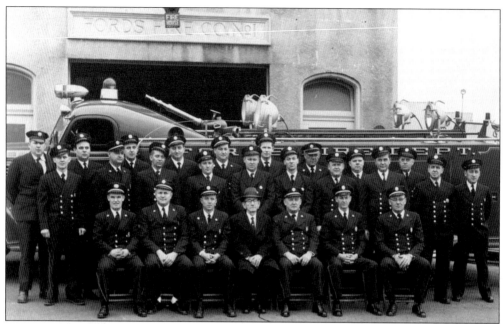

The members of the fire company have always taken their responsibilities very seriously—from 1912, when the opening of Fords Porcelain Works brought piped water to the town (the factory could not operate using well water), allowing for the strategic placement of fire hydrants around town, to keeping their equipment in the best order possible, for example the pumper truck, shown in 1959. (Courtesy Fords Fire Company No. 1.)

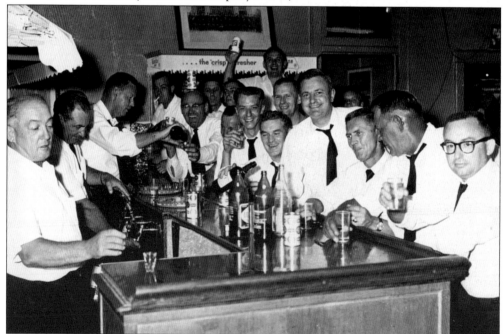

The members have always shared a sense of camaraderie, working together as part of an extended family. This 1961 photograph shows the men taking a little time to relax. (Courtesy Fords Fire Company No. 1.)

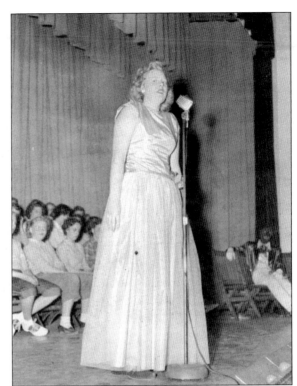

The fire company also provided a social function for the community during its long history. Shows like this one were presented for entertainment and to help raise funds for the operation of the firehouse. The performers included members of the community and family members of the firemen. (Courtesy Fords Fire Company No. 1.)

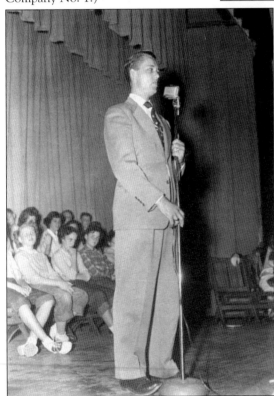

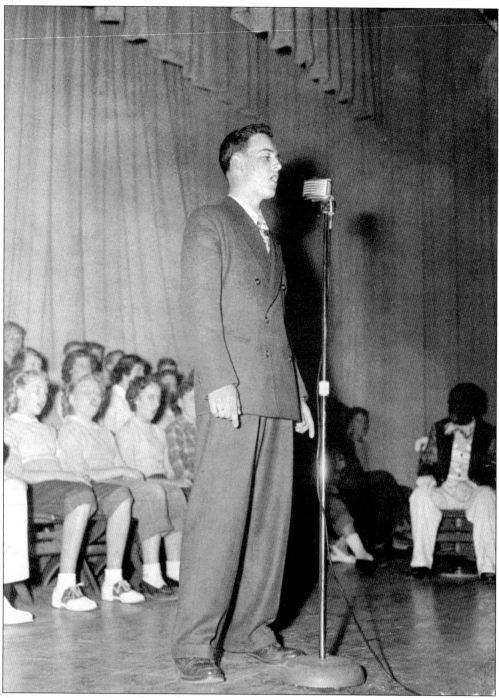

A singer entertains the audience during this fund-raiser. Copies of these photographs were also sold to raise money. (Courtesy Fords Fire Company No. 1.)

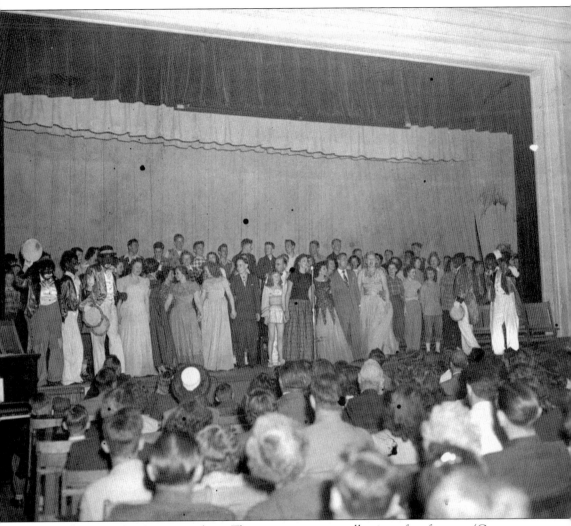

Shown is the finale of a variety show. The cast was quite a collection of performers. (Courtesy Fords Fire Company No. 1.)

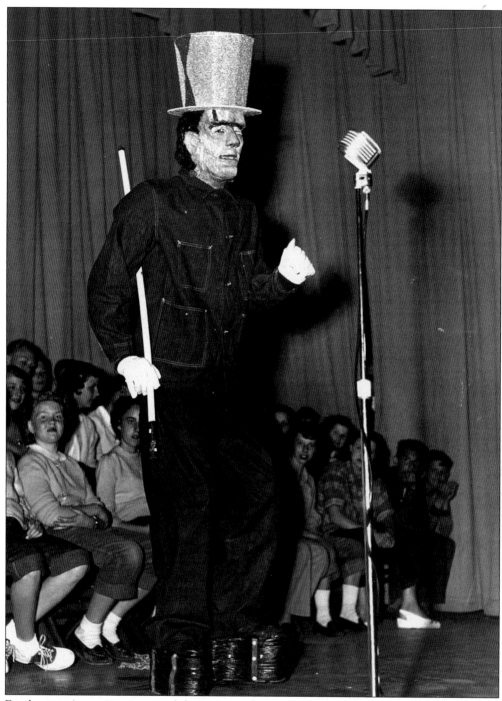

Frankenstein's monster was a real showstopper during a variety show performance sponsored by Fords Fire Company No. 1. (Courtesy Fords Fire Company No. 1.)

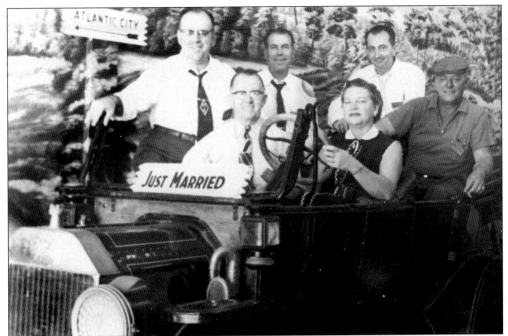

The annual convention for firefighters used to be held in Atlantic City. This photograph shows some members of the Fords Fire Department posing for a novelty photograph as a souvenir. From left to right are the following: (front seat) J. Dambach and Mrs. L. Turkus; (back seat) L. Turkus, J. Dudik, J. Fischer, and G. Ferdinandsen. (Courtesy Fords Fire Company No. 1.)

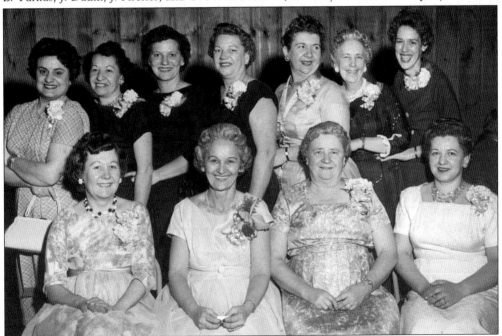

The wives of members of Fords Fire Company No. 1 pose in 1959 during the annual ex-chiefs dinner. The women were always welcome at these social functions, but the members never wanted an official ladies auxiliary. (Courtesy Fords Fire Company No. 1.)

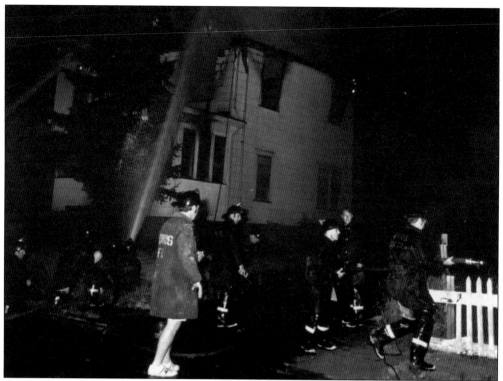

Called during the night to battle a house fire, volunteers for Fords Fire Company No. 1 rush to put out the blaze. (Courtesy Fords Fire Company No. 1.)

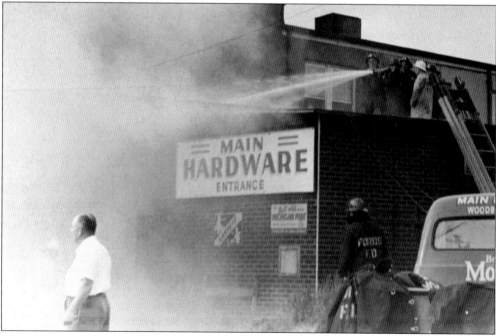

Some members fight a fire on New Brunswick Avenue by climbing on the roof in order to better douse the flames. (Courtesy Fords Fire Company No. 1.)

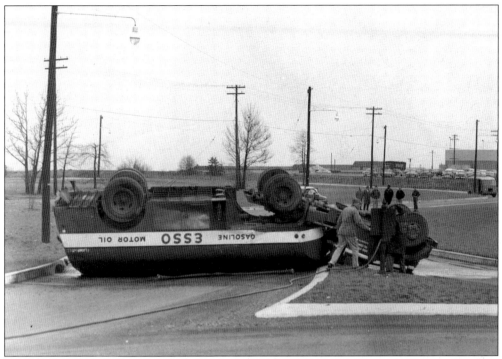

The fire department also responded to situations where there was a danger of fire, as in this case when a gasoline tanker overturned near Fords Park. The fuel spill could have resulted in a fire and explosion. (Courtesy Fords Fire Company No. 1.)

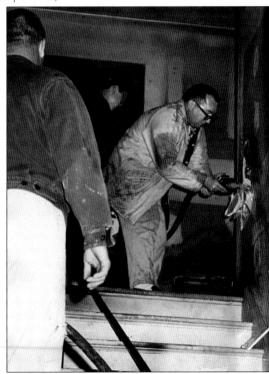

On May 2, 1965, the fire department investigated a suspected case of arson after putting out the fire. This was before the time of specially designated arson investigation units. (Courtesy Fords Fire Company No. 1.)

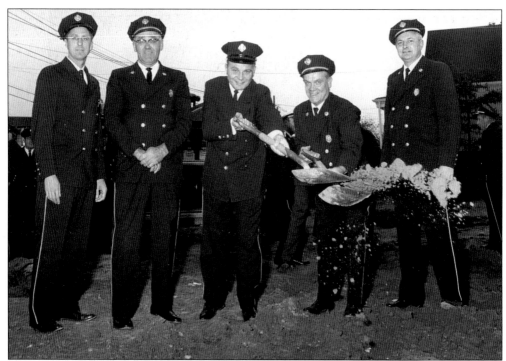

The end of World War II brought more development to Fords; farms decreased and housing developments arose. Fords Fire Company No. 1 began to augment its roster with paid firemen to ensure constant coverage for the town. In 1961, there were 50 volunteers, 4 paid men, and 2 engines in the company, and the small firehouse on Corrielle Street was becoming cramped. In 1966, ground was broken for a new firehouse on King George Road.

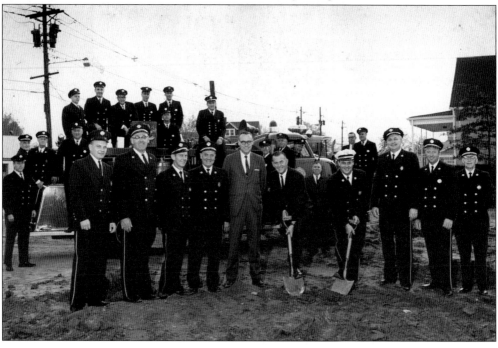

In 1956, John Mizerny stands by the newest pumper in front of the garage door of the firehouse on Corrielle Street. For years, Mizerny was very active in the department and served as its photographer for much of that time. (Courtesy Fords Fire Company No. 1.)

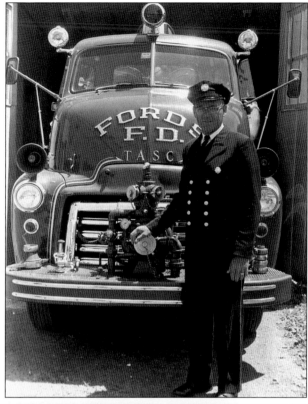

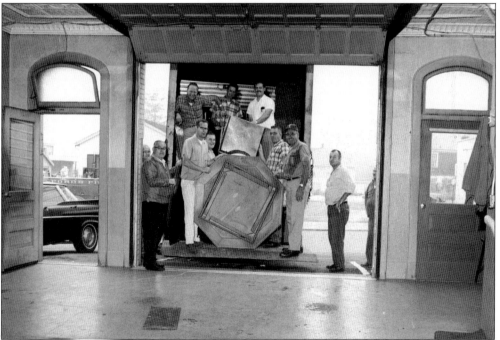

On moving day in 1967, members leave Corrielle Street for their new headquarters on King George Road. (Courtesy Fords Fire Company No. 1.)

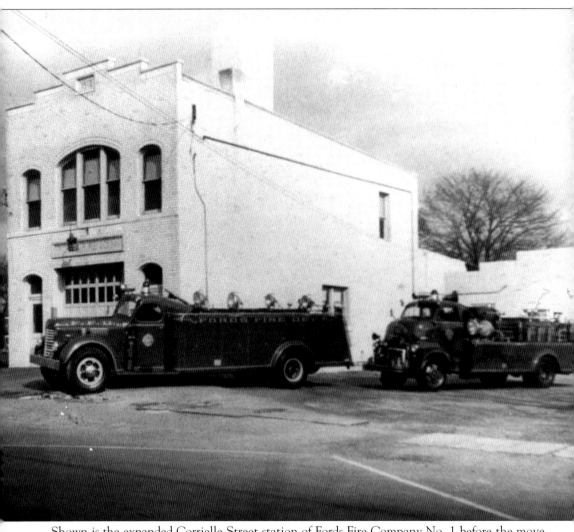

Shown is the expanded Corrielle Street station of Fords Fire Company No. 1 before the move to the new firehouse. (Courtesy Fords Fire Company No. 1.)

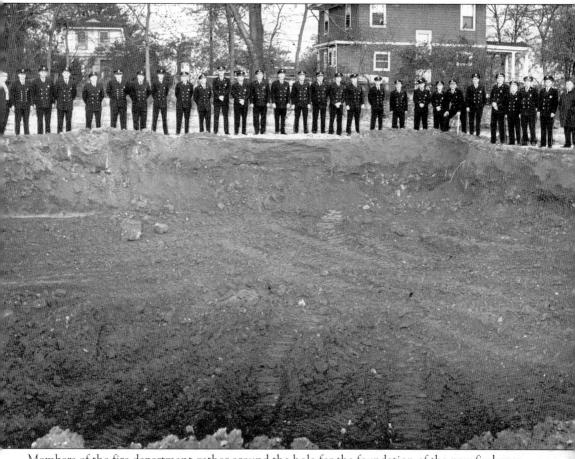

Members of the fire department gather around the hole for the foundation of the new firehouse at the end of 1966. (Courtesy Fords Fire Company No. 1.)

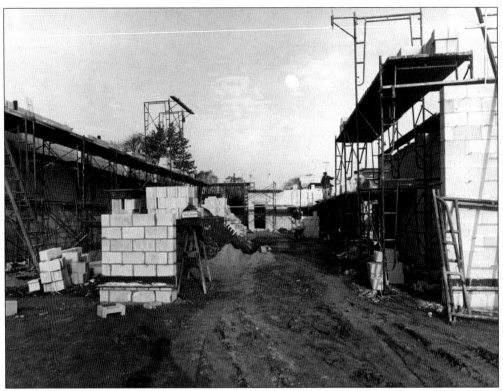

With a cost of $134,000, the new firehouse was the largest construction project the fire company had ever considered. This December 1966 photograph captures the scale of the work. (Courtesy Fords Fire Company No. 1.)

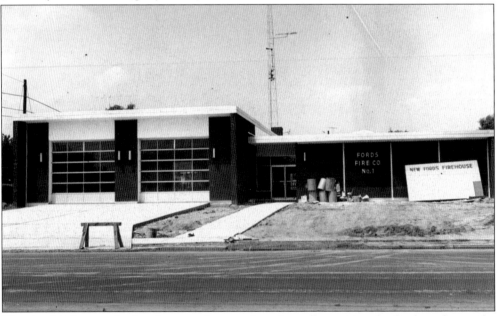

The sign for the new fire headquarters leans against the wall, awaiting the final touches to the project, which is just about finished. (Courtesy Fords Fire Company No. 1.)

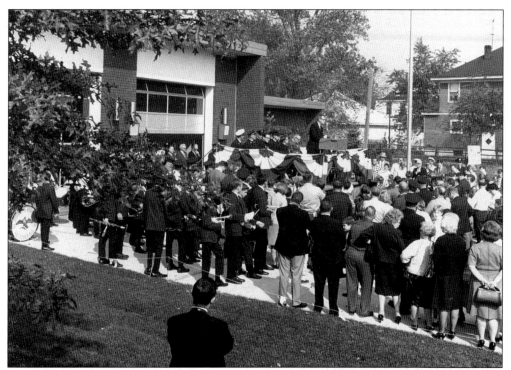

Dedication ceremonies are held for the new fire department headquarters on King George Road. The facility contained two truck bays, sleeping quarters, an alarm room, meeting room, offices for the chief and fire commissioners, and recreation room for the members. (Courtesy Fords Fire Company No. 1.)

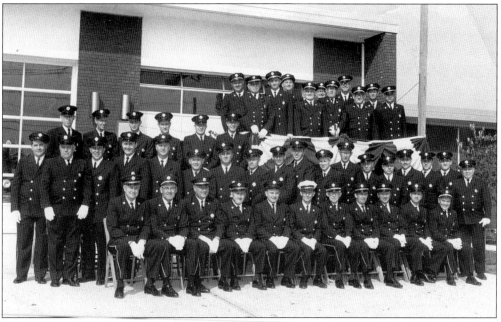

Following the dedication and wet down of the new building, the officers and members pose in front of the speakers platform. (Courtesy Fords Fire Company No. 1.)

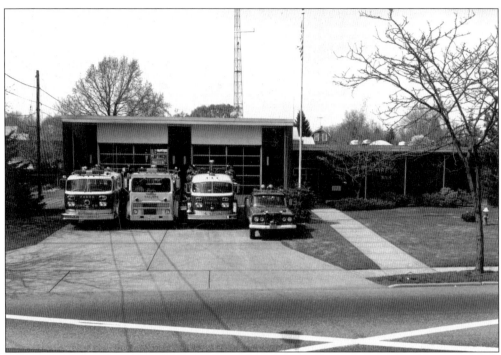

The trucks and the chief's car sit outside the firehouse, ready for any action. (Courtesy Fords Fire Company No. 1.)

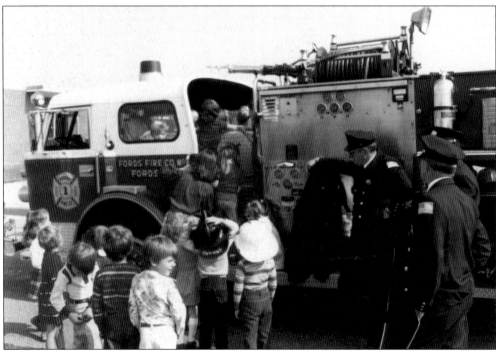

Members of Fords Fire Company No. 1 conduct an open house and give fire-prevention tips to youngsters during Fire Prevention Week. (Courtesy Fords Fire Company No. 1.)

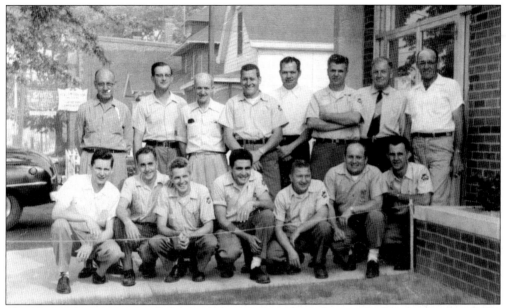

These were the employees of the Fords Post Office when the new building opened in 1957. From left to right are the following: (front row) Tom Gockel, Charles Moore, Joe Egan, John Verducci, William Reicz, John Brennan, and Joe Stek; (back row) Hans Lund, William Nalepa, Ken Van Horn, Edward Paszinski, Walter Skarzinski, Leo Carasiti, Henry Anderson, and John Mizerny. (Courtesy Tom Gockel.)

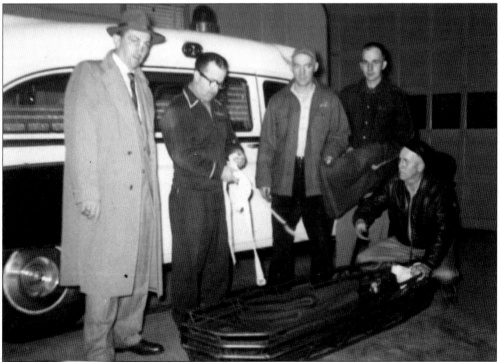

St. John's First Aid Squad is a volunteer service organization in Fords. Members inspect new equipment inside the squad's headquarters during the 1950s. (Courtesy Fords Fire Company No. 1.)

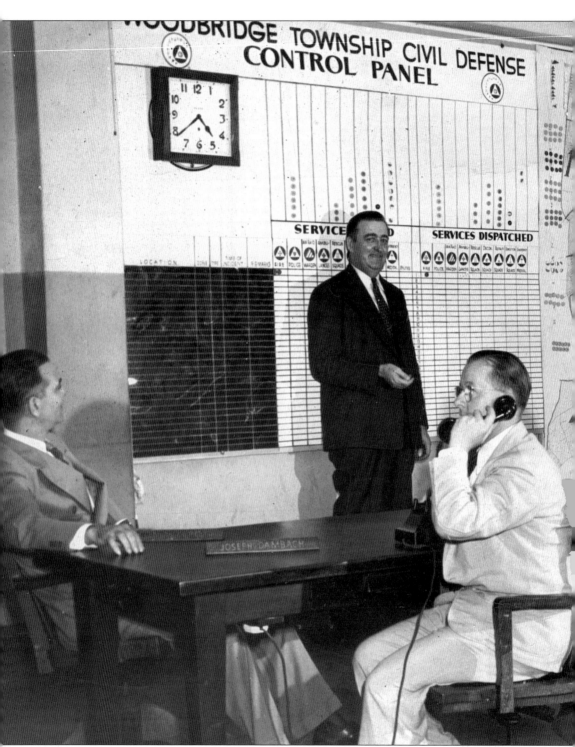

Fords residents participated in many ways to protect the lives and property of the citizens of the township. This 1941 photograph includes members of the Woodbridge Township Civil Defense Council of World War II. From left to right are the following: (seated, foreground) Joseph A.

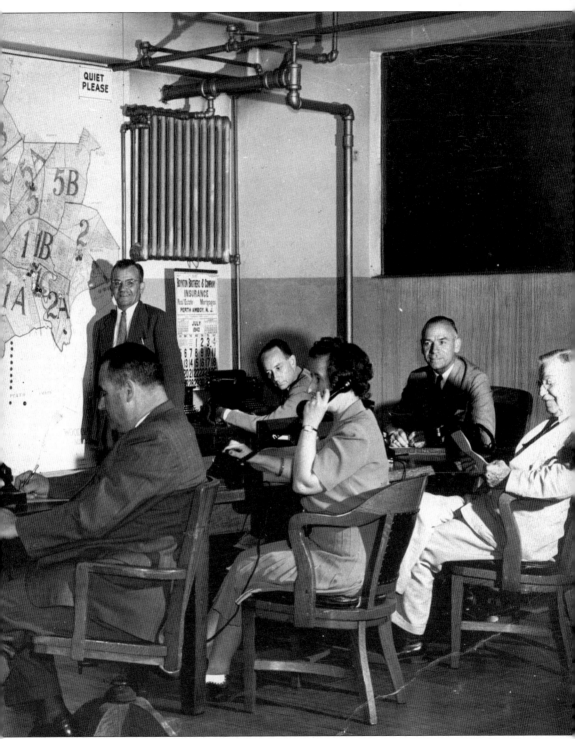

Dambach, head of fire reserves; John Egan, a police captain; Mrs. George Hunter; Dr. Ira T. Spencer; and Mayor August Greiner; (seated, far corner) Charles E. Gregory, (standing) Leon E. McElroy, George Keating, and William Allgaier. (Courtesy Woodbridge Public Library.)

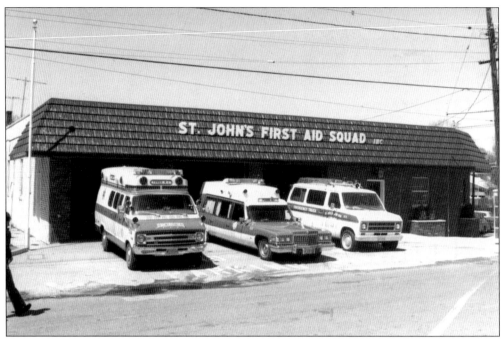

The ambulances of St. John's First Aid Squad sit in front of the squad's building. (Courtesy Fords Fire Company No. 1.)

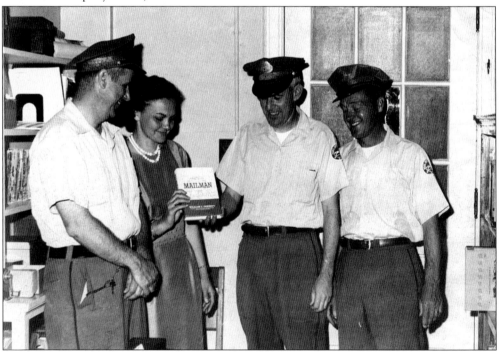

In 1959, the letter carriers of the Fords Post Office presented a book to be used in the library of School No. 7 in Fords. The book was aptly titled *Mailman*, and it gave students some insight into the importance of the role the postman. From left to right are Leo Carasiti, the librarian of School No. 7, Joseph Egan, and John Nascak. (Courtesy Tom Gockel.)

Four
CLUBS AND RECREATION

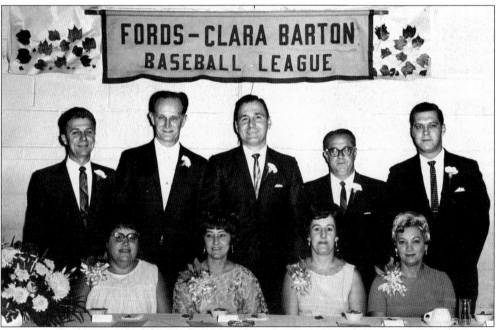

The Fords-Clara Barton Baseball League was the organization that ran baseball teams for the youth of Fords. Little League got its start in 1951, when Father Grimes and some members of the Holy Name Society of Our Lady of Peace started the first teams for boys. Later, the organization grew to form the Fords-Clara Barton Boys' Baseball League, which had three divisions, based on age: Midgets, Minors, and Majors. Shown are the league officers and their wives at the annual dinner in 1967. (Courtesy Pete Dalina.)

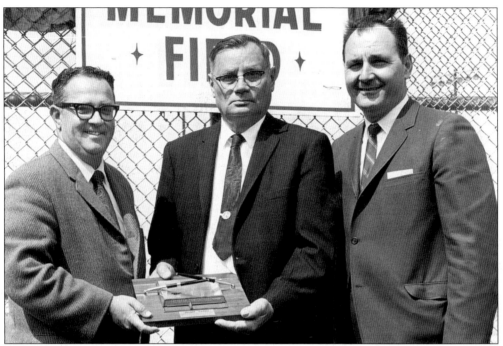

This photograph was taken during an awards ceremony at Memorial Field organized by the Fords-Clara Barton Little League in the late 1960s. From left to right are Matthew Jago, Stephen Dalina, and Pete Dalina. Stephen Dalina sponsored many of the teams for years. (Courtesy Pete Dalina.)

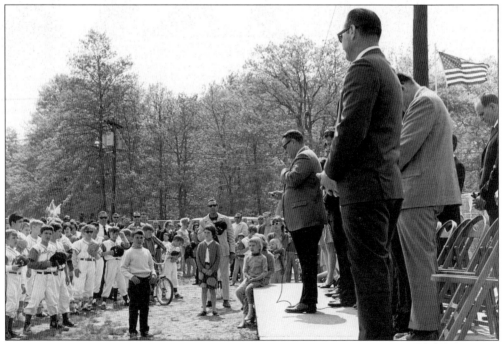

Opening-day ceremonies are held after the parade for the Fords-Clara Barton Little League in 1966. (Courtesy Pete Dalina.)

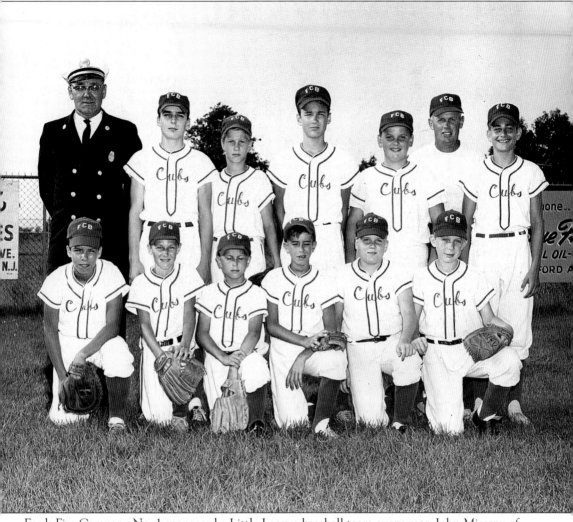

Fords Fire Company No. 1 sponsored a Little League baseball team every year. John Mizerny of the fire department poses with the Cubs, who were sponsored by the fire company. (Courtesy Fords Fire Company No. 1.)

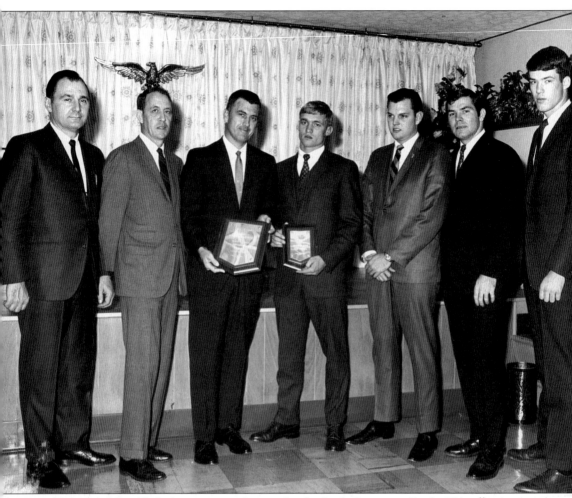

Father and Son Night was an annual event for the Little League in Fords. The officers invited well-known sports figures to speak at the dinner. From left to right are Pete Dalina; Art Richmond; Artie Peterson, general manager of the Pittsburgh Pirates; ? Tilka; Bill Hands, pitcher with the Chicago Cubs; Ron Swoboda, outfielder with the New York Mets; and a Rutgers athlete. (Courtesy Pete Dalina.)

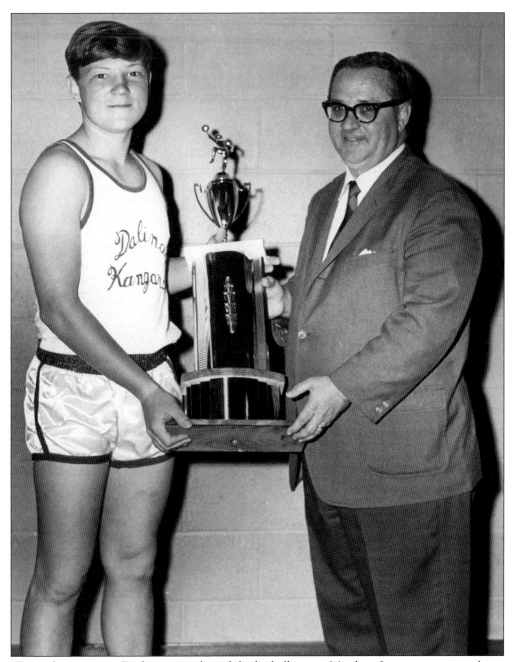

Various businesses in Fords sponsored youth basketball teams. Matthew Jago presents a trophy to a member of Dalina's Kangaroos, a team sponsored by Dalina's Tavern. (Courtesy Pete Dalina.)

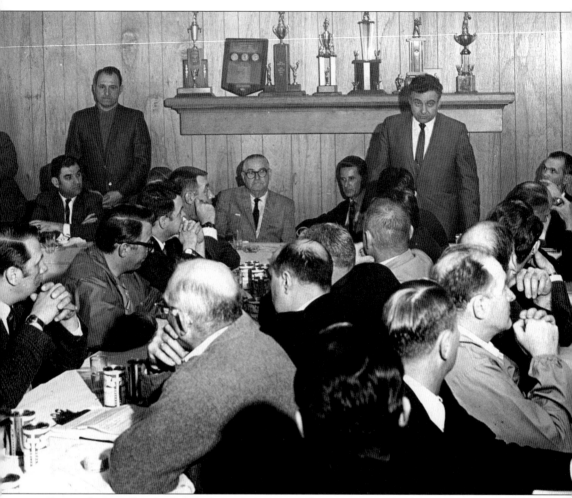

Pictured is a well-attended Fords Little League Officers Dinner. Standing from left to right are Pete Dalina and Mayor Ralph Barone. The mayor was often asked to speak at these dinners to thank the men of the community for supporting the youth of Fords. (Courtesy Pete Dalina.)

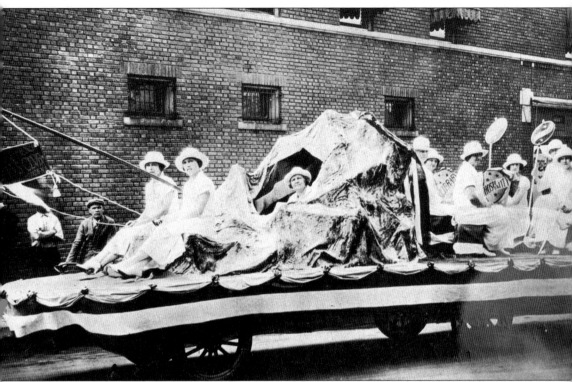

This float was sponsored by the Fords Woman's Club in the 255th Anniversary Parade of Woodbridge Township on June 14, 1924. The Woman's Club was founded in October 1920 with the purpose of providing an organization through which women, "putting aside personal prejudices, may work for the betterment of the community." During the Great Depression, the club helped the needy before public relief was instituted. The group sold war bonds during World War II and helped in USO centers. The club achieved its main goal of providing library services to the community by organizing a free library in rented quarters, staffed by volunteers, in 1924. In 1940, Our Redeemer Lutheran Church donated its chapel to the club for use as the Fords Public Library, which the club operated until 1964, when the municipal library was started. (Courtesy Woodbridge Public Library.)

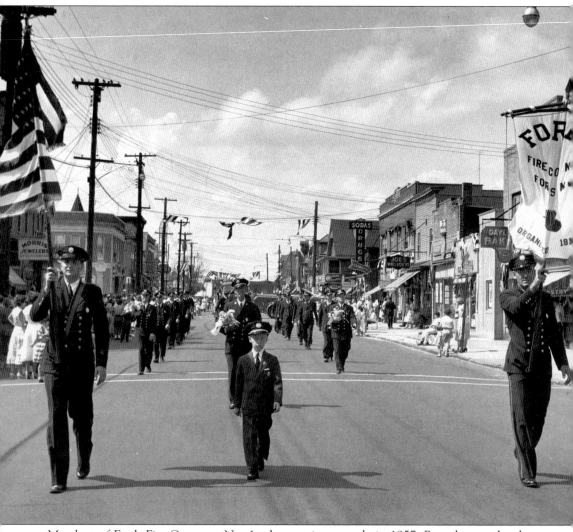

Members of Fords Fire Company No. 1 take part in a parade in 1957. Brought together by a desire to be volunteer firefighters, the members became a close group that socialized together and participated in community events like this one. (Courtesy Fords Fire Company No. 1.)

Five

FACES OF FORDS

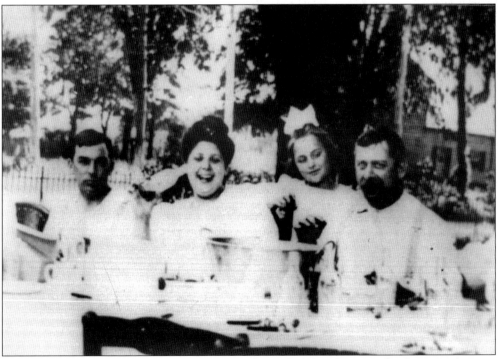

Members of the Liddle family enjoy a picnic in the yard of their home under the great elm tree, which stood for more than 100 years. The Liddles had a blacksmith shop on their property. Their home and that of the Fords (background, across the street) stood at the intersection of King George Road and New Brunswick Avenue—Fords Corner. Our Lady of Peace Church, the First National Bank, and other commercial enterprises were built on the site in later years. (Courtesy Woodbridge Public Library.)

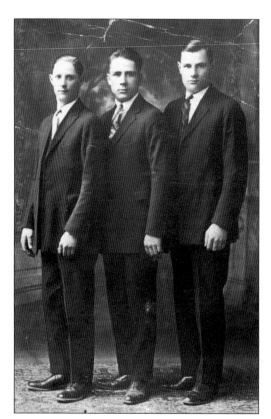

Three members of the Dalina family pose during the 1930s for a studio portrait. Such portraits became popular as professional photography became more affordable. They were one way of showing family and friends that things were going well. From left to right are Frank, Stephen, and Joseph Dalina. (Courtesy Pete Dalina.)

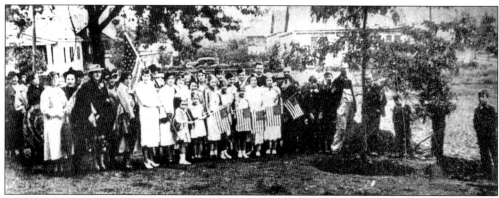

Taking part in a tree-planting ceremony are members of the Fords American Legion Auxiliary Post No. 163. They are planting the a tree on the grounds of School No. 7 in Fords. (Courtesy Woodbridge Public Library.)

Shown are Pete and Joe Dalina in 1939. Could the shiny new bicycle in the background be the reason for the picture? (Courtesy Pete Dalina.)

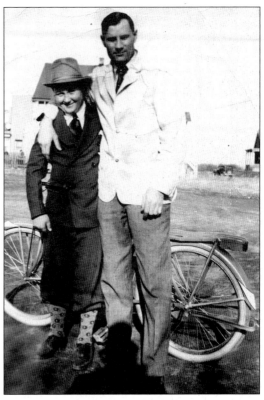

One of the Dalina brothers poses with a hunter returning from a deer-hunting expedition. (Courtesy Pete Dalina.)

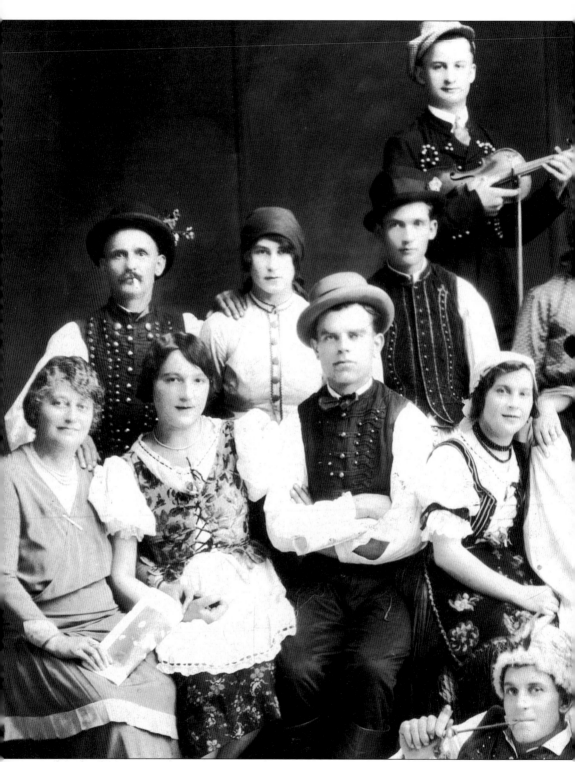

Before Dalina's opened as a tavern in 1934, it served other purposes. The building had been a barbershop and later a theater, which was often used by the large Hungarian population to stage

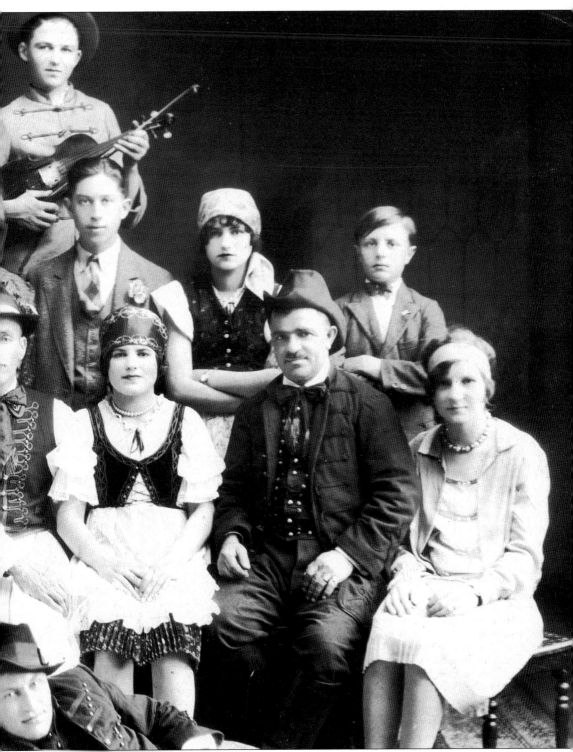

plays in Hungarian. Sarolta Dalina, mother of Stephen "Pete" Dalina, often performed. (Courtesy Pete Dalina.)

This is young Stephen Kermondy in 1937. His father, Stephen Kermondy Sr., and his mother, Helen Bodnar Kermondy, came from families who lived in Fords from its early farming days to the present day. (Courtesy Stephen Kermondy.)

Stephen Kermondy's sister Margaret Kermondy poses at the age of three. (Courtesy Stephen Kermondy.)

Helen Kermondy makes homemade noodles in the kitchen of her home on Main Street in the 1950s. The traditions of the past in cooking and culture were passed on from generation to generation. (Courtesy Stephen Kermondy.)

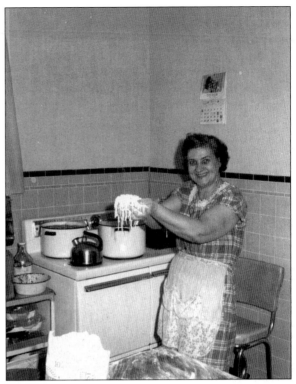

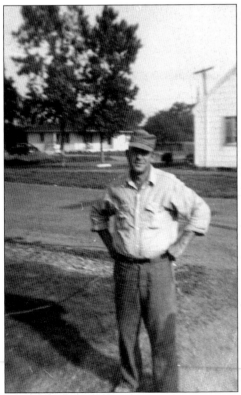

Stephen Kermondy Sr. is shown in the driveway of his home in the 1940s. The farmland of the past was starting to make way for new homes and, later, housing developments. (Courtesy Stephen Kermondy.)

Stephen Kermondy Jr. is pictured in the backyard of the family home on Main Street in Fords in 1949. Local families still kept chickens and tended large vegetable gardens to supply their own tables and provide a good crop for canning and winter use. (Courtesy Stephen Kermondy.)

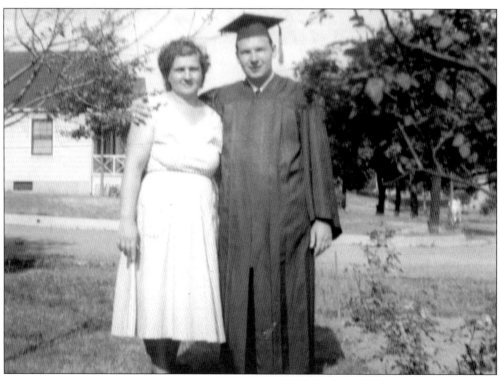

Following his graduation from Woodbridge High School in 1937, Stephen Kermondy Jr. stops for a word with his mother, Helen Kermondy. At the time, Woodbridge High was the only high school in the township. (Courtesy Stephen Kermondy.)

108

Pictured in the 1940s is Mary Bodnar, in front of her home, where she and her husband, John Bodnar, raised chickens, cows, and pigs. John Bodnar also worked in the clay mines. (Courtesy Stephen Kermondy.)

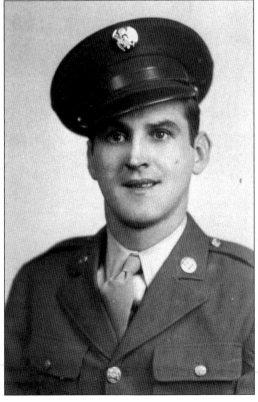

Like many other Fords residents, Frank Bodnar, son of Mary and John Bodner, answered the call to serve during World War II. He is shown in uniform. (Courtesy Stephen Kermondy.)

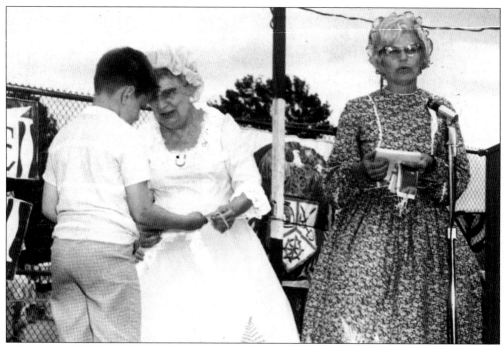

The celebration of the 300th anniversary of the township of Woodbridge in 1969 was a major event for the residents. Numerous programs and exhibits were planned throughout the year. One of the largest was an anniversary fair held in Merrill Park in Iselin. At that fair, Ruth Wolk (left) and art exhibit chairperson Mary Molnar of Fords hand out awards to the winning artists. (Courtesy Woodbridge Public Library.)

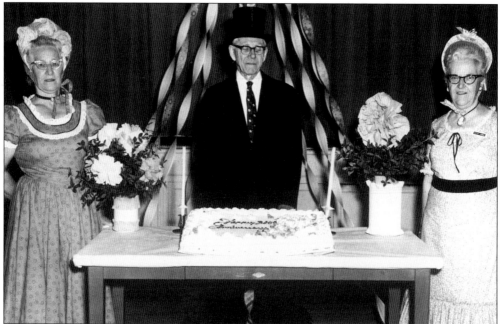

The Fords Senior Citizens present a program for the 300th anniversary celebration. (Courtesy Woodbridge Public Library.)

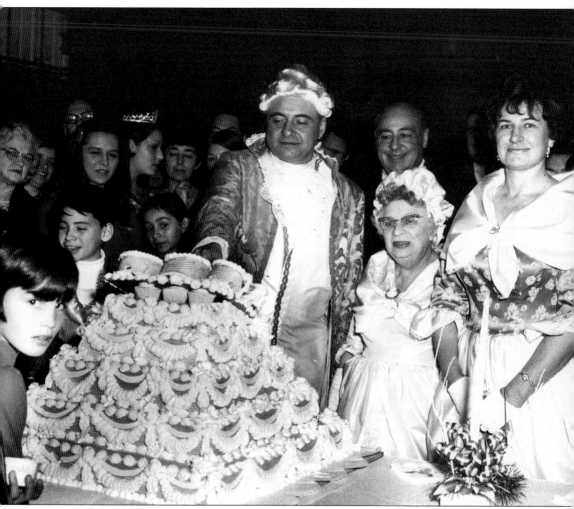

With everyone ready to sing "Happy Birthday" to Woodbridge, the celebration of the 300th anniversary gets under way. This reception opened the tercentenary on January 1, 1969. Mayor Ralph Barone, Ruth Wolk, and Elizabeth Novak of Fords, chair of the reception, cut the huge birthday cake. (Courtesy Woodbridge Public Library.)

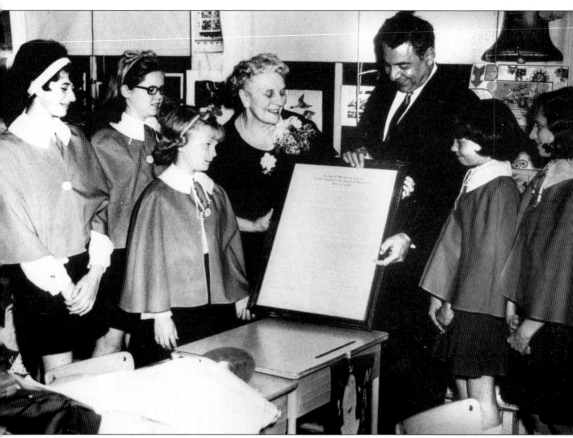

Mayor Ralph Barone presents a copy of the charter for Woodbridge Township to pupils from School No. 7 in Fords to honor them for performing a history of the township in story and song during the 300th anniversary celebration. The performance was called *Ode to Woodbridge Township*. (Courtesy Woodbridge Public Library.)

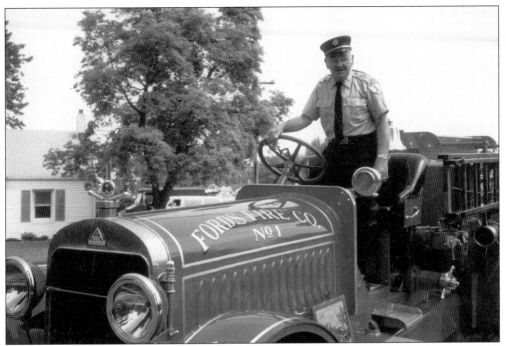

A member of Fords Fire Company No. 1 shows off the old Stutz truck after it was restored. A photograph from its early days in service sits on the running board. (Courtesy Fords Fire Company No. 1.)

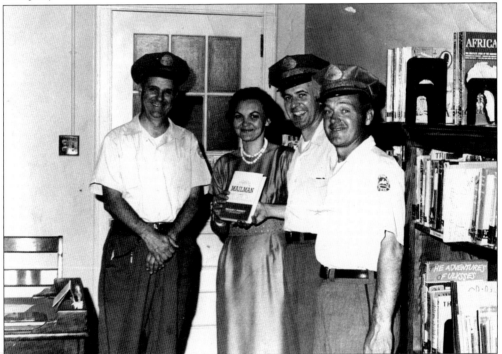

Three letter carriers and a librarian in Fords are photographed after they presented a book to be used by schoolchildren to help learn about the postal service. (Courtesy Tom Gockel.)

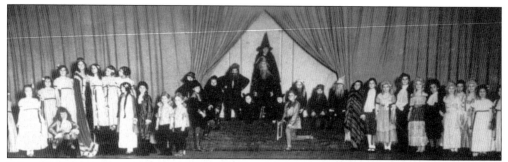

Schoolchildren perform in a play at School No. 7 in Fords. The schools always included artistic and cultural events, as well as scholarly pursuits. (Courtesy Woodbridge Public Library.)

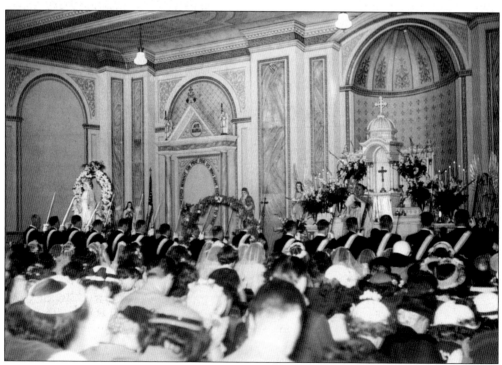

Members of the congregation bow their heads during a May crowning in Our Lady of Peace Church during the 1940s. The Knights of Columbus stand in front of the church with their swords raised. (Courtesy Our Lady of Peace Church.)

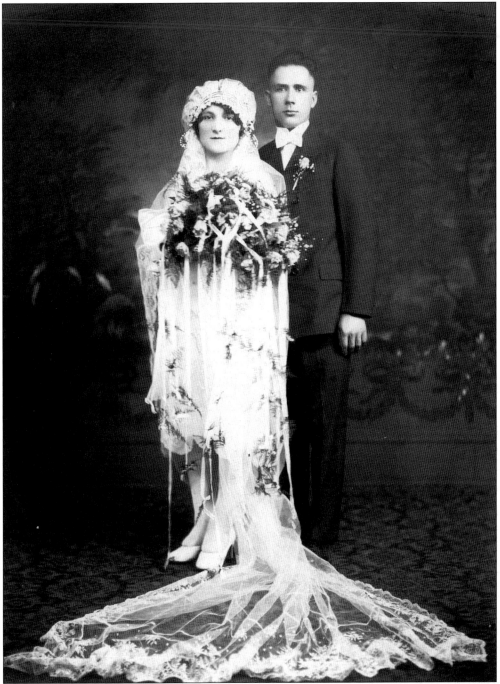

Stephen and Sarolta Dalina are shown on their wedding day in 1926. (Courtesy Pete Dalina.)

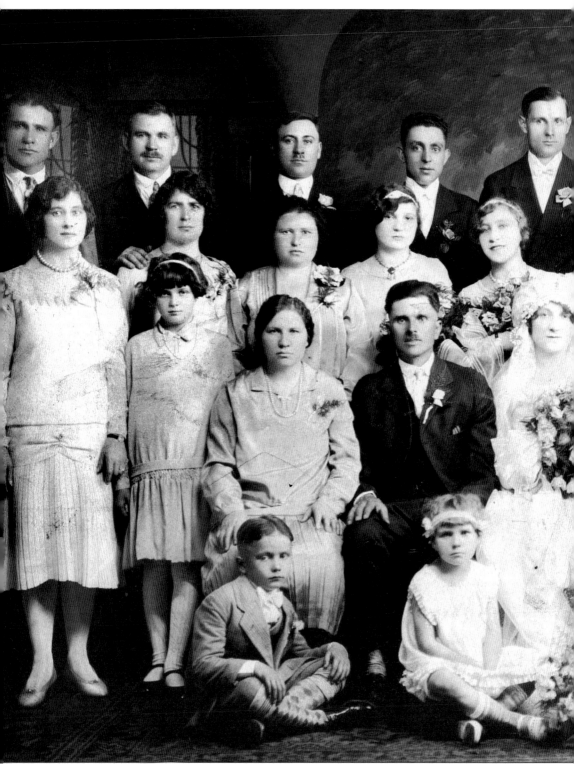

This picture shows the entire wedding party of Stephen and Sarolta Dalina, together with the

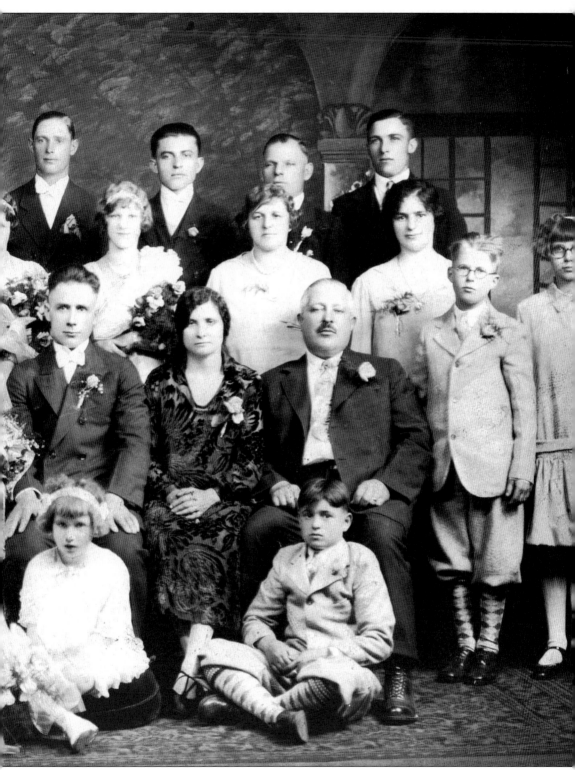

parents of the bride and the groom. (Courtesy Pete Dalina.)

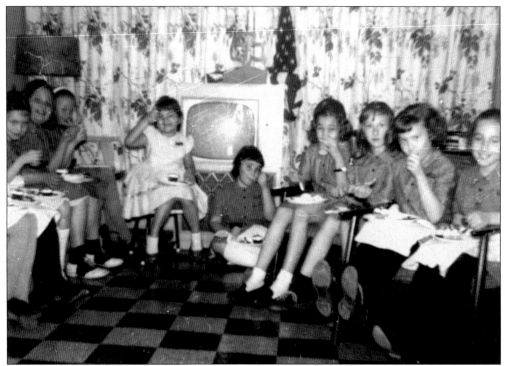

Brownie Troop No. 175 meets in Fords in 1960. The town also had troops of Girls Scouts, Cub Scouts, and Boy Scouts. The baby boom helped increase the popularity of organizations for youngsters, as their parents looked to find after-school interests for their children.

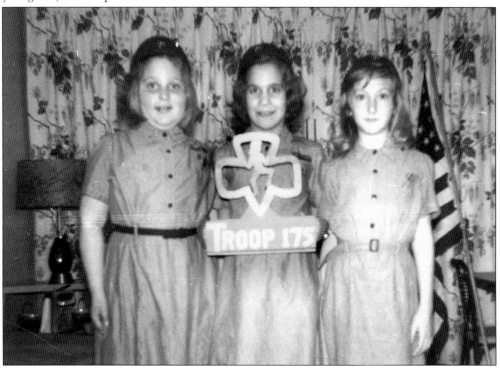

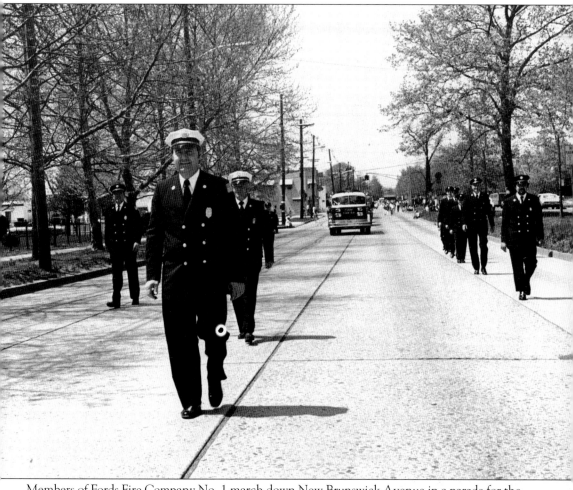

Members of Fords Fire Company No. 1 march down New Brunswick Avenue in a parade for the Fords-Clara Barton Little League opening day in 1974. The fire company has always come out to march in parades for the opening of Little League, for Memorial Day, and for Township Holiday, as well as for its own anniversary parades. (Courtesy Fords Fire Company No. 1.)

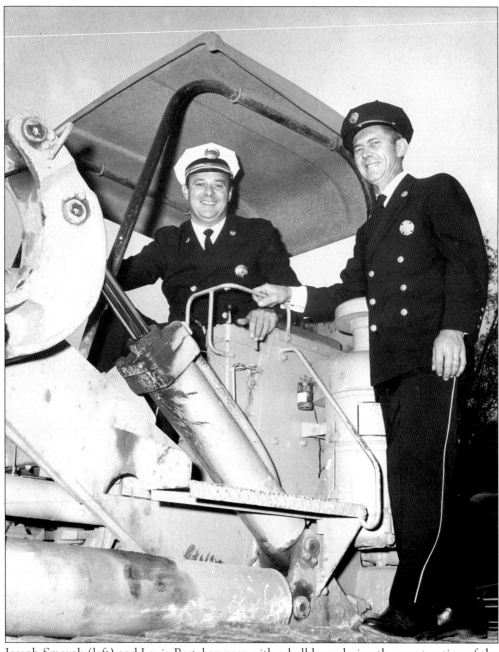

Joseph Smoyak (left) and Louie Bertekap pose with a bulldozer during the construction of the new firehouse in Fords in 1966. (Courtesy Fords Fire Company No. 1.)

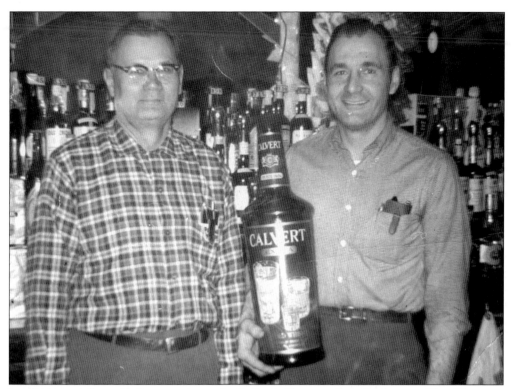

Joe (left) and Steve Dalina are shown in Dalina's Tavern when drinks cost 35¢. (Courtesy Pete Dalina.)

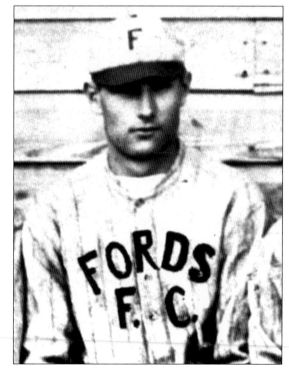

This player is a member of the Fords Field Club baseball team. Although early in the 20th century there was no Little League or other group to provide recreation, there were some privately run teams. The Fords Field Club used to play on a field on Liberty Street c. 1915. (Courtesy Pete Dalina.)

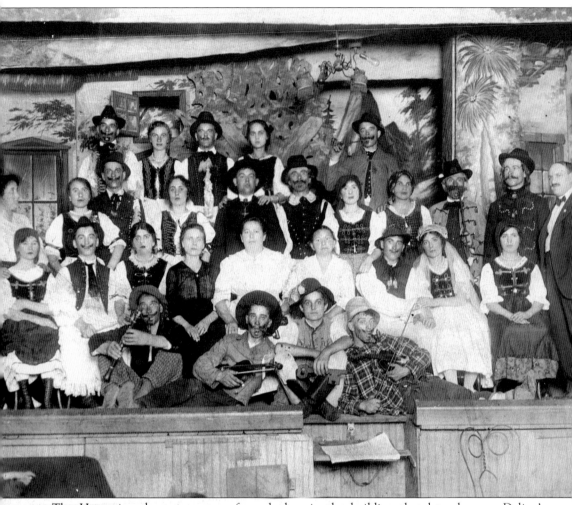

The Hungarian theater group performed plays in the building that later became Dalina's Tavern, on Crows Mill Road in Fords. These performances helped keep the Hungarian culture alive for the families of Hungarian immigrants in Fords and provided entertainment and a chance to socialize with neighbors and friends. (Courtesy Pete Dalina.)

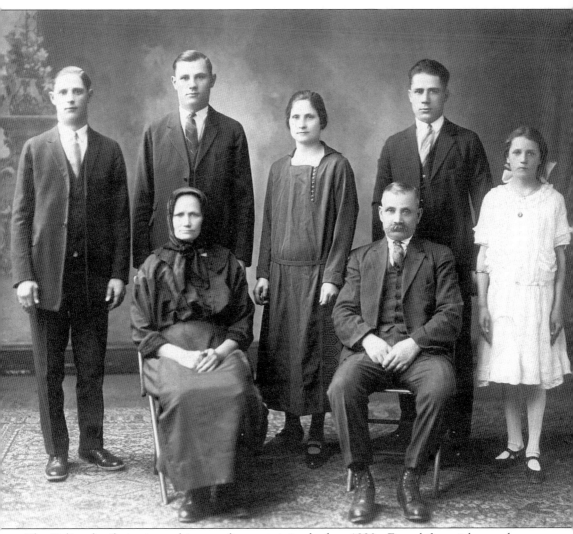

The Dalina family is pictured in a studio portrait in the late 1920s. From left to right are the following: (front row) Mary and John; (back row) Steve, Joe, Margaret, Frank, and Elizabeth.

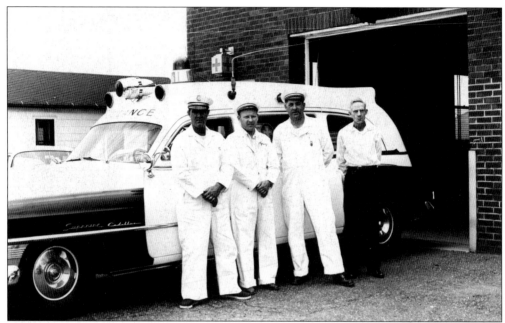

Members of the St. John's First Aid Squad pose beside their Cadillac ambulance in front of the squad building. The squad was staffed by volunteers who underwent extensive training so they could provide emergency services to Fords residents when the need arose. (Courtesy Fords Fire Company No. 1.)

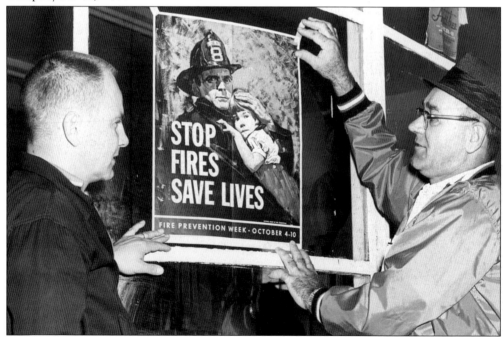

In 1965, two members of the Fords Fire Company put up a poster reminding citizens of Fire Prevention Week, which takes place in October each year. The firefighters have always incorporated into their regular services the promotion of fire prevention. (Courtesy Fords Fire Company No. 1.)

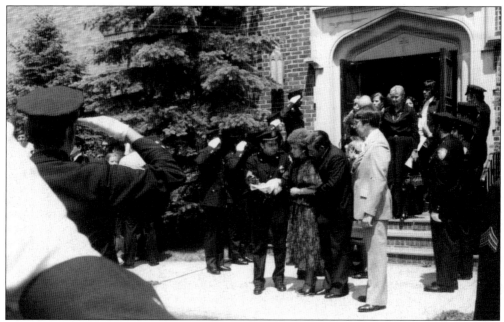

Teresa Koebel, the widow of Henry John "Chuck" Koebel, stands outside Our Redeemer Lutheran Church in Fords in 1978 with family and officers from the New York City Port Authority Bus Terminal. Teresa and Henry Koebel lived most of their lives in Fords and had just purchased a home of their own in town shortly before he died at age 26, becoming the first Port Authority officer to be killed in the line of duty. He was killed in the New York bus terminal while trying to protect rush-hour crowds from a deranged man. (Courtesy Teresa Koebel.)

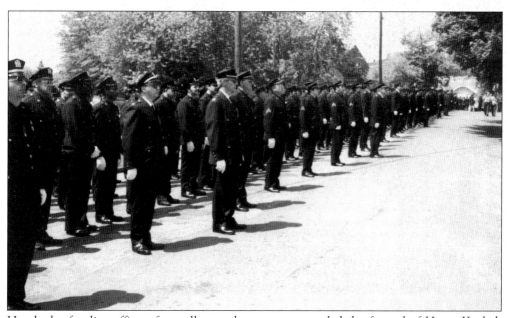

Hundreds of police officers from all over the country attended the funeral of Henry Koebel. Because the numbers were far too great to fit inside Our Redeemer Church, the officers stood at attention on both sides of Ford Avenue during the service. (Courtesy Teresa Koebel.)

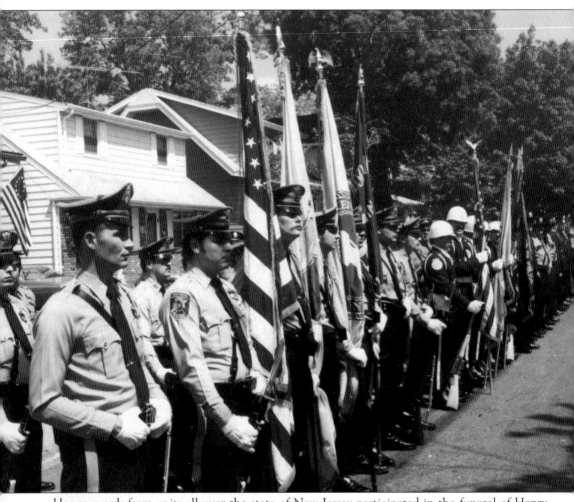

Honor guards from units all over the state of New Jersey participated in the funeral of Henry Koebel. Ford Avenue was closed to all traffic during the service. (Courtesy Teresa Koebel.)

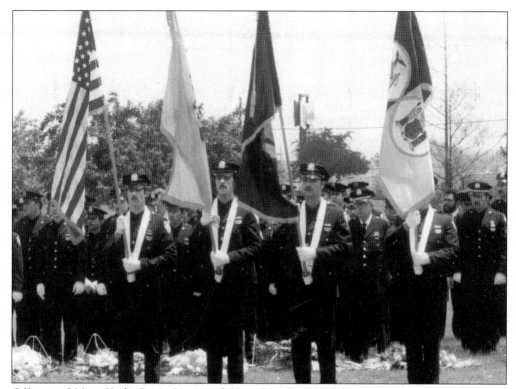

Officers of New York City's Port Authority Bus Terminal formed an honor guard at the cemetery during the funeral of Henry Koebel. The funeral procession stretched for miles, as representatives of police units traveled by car, van, and bus to attend the burial. (Courtesy Teresa Koebel.)

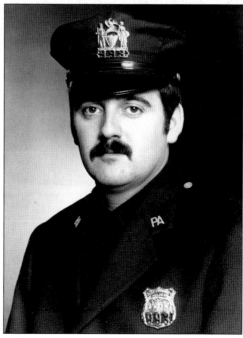

Henry John Koebel of Fords, an officer at the Port Authority Bus Terminal in New York, died while trying to protect rush-hour crowds from a deranged man. He was honored by the Port Authority for heroism in the line of duty. Known as "Chuck," a childhood nickname, he grew up in a house in Lafayette Estates, where he met Teresa, whom he later married. He was almost 27 at the time of his death. (Courtesy Teresa Koebel.)

BIBLIOGRAPHY

Clayon, W. Woodford, editor. *History of Union and Middlesex Counties, New Jersey.* Philadelphia: Everts and Peck, 1882.

Dally, Joseph. *Woodbridge and Vicinity.* Woodbridge, New Jersey, 1873.

Ludewig, F.D. Dorothy. *Fords Yesterday and Today.* Woodbridge, New Jersey: Independent Leader, 1964.

Ludewig, F.D. Dorothy. *Timely Told Tales of Woodbridge Township.* Plainfield, New Jersey: Boise Printing Company, 1970.

Wolk, Ruth. *The History of Woodbridge, New Jersey.* Woodbridge, New Jersey, 1970.